A Black Gaze

A Black Gaze

Artists Changing How We See

Tina M. Campt

The MIT Press

Cambridge, Massachusetts

London, England

The MIT Press would like to thank the anonymous peer reviewers who provided comments on drafts of this book. The generous work of academic experts is essential for establishing the authority and quality of our publications. We acknowledge with gratitude the contributions of these otherwise uncredited readers.

This book was set in Freight and Halyard—typefaces designed by Joshua Darden—by the MIT Press. Printed and bound in the United States of America.

Publication of this book has been aided by a grant from the Wyeth Foundation for American Art Publication Fund of CAA.

**Advancing
Art&Design**

Library of Congress Cataloging-in-Publication Data

Names: Campt, Tina, 1964– author.
Title: A black gaze : artists changing how we see / Tina M. Campt.
Description: Cambridge, Massachusetts : The MIT Press, [2021] | Includes bibliographical references and index.
Identifiers: LCCN 2020037098 | ISBN 9780262045872 (hardcover)
Subjects: LCSH: Aesthetics, Black. | Arts, Black—21st century. | Arts and society—History—21st century.
Classification: LCC BH301.B53 C36 2021 | DDC 704.03/96073—dc23 LC record available at https://lccn.loc.gov/2020037098

10 9 8 7 6 5 4 3 2 1

To AJ, who opened the door,

and Saidiya, who pushed me through . . .

Contents

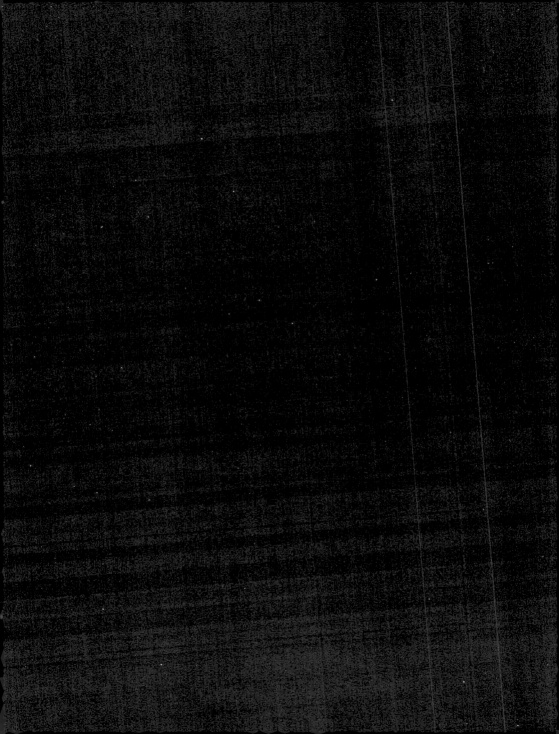

Prelude to a Black Gaze

"I broke the Internet, ya'll." It was the first thing he said as he walked through the front door, dragging the massive case that had become his trademark accessory. He's the only person I know who travels with a desktop. He places no trust in external hard drives or laptops. He's only comfortable when he has direct access to his entire archive, because you never know what you might need.

"What do you mean, you broke the Internet?" We posed the question in feigned disbelief because, knowing AJ, anything was possible. "I always wanted to be able to say I broke the Internet, but I never thought I'd actually be able to do it," he continued, chuckling sheepishly. "But what exactly do you mean? How did you break the Internet?" we asked again, this time with a combination of impatience and anticipation of the story to come.

The summer of 2017 in London was one of those glorious summers that (prior to global warming) was a rare occurrence. It was hot and sunny, and it hadn't rained in days. And for precisely this reason, it was the kind of summer in London I never actually trusted. Something about the way AJ shook his head and chuckled like a big kid who couldn't believe his luck felt somehow similar: an appreciation tinged with disbelief in anticipation of something new that was just beginning to come into view.

It was the same feeling I had experienced a year before when I watched one of his recently completed films on my computer and found myself trying to move my seat closer and closer to the screen. Somehow I couldn't get close enough. It was like nothing I'd ever seen before—a video that made me grin and giggle with delight at its gorgeous images of Black people in all their vexed glory, and a split second later, moved me to tears of rage at the endless cycle of violence and suffering it depicted directly alongside so many uplifting scenes of Black joy and pleasure.

I had met Arthur Jafa (known to friends and fans as AJ) in August 2016. He had recently finished *Love Is the Message, The Message Is Death*, the video I couldn't get my seat close enough to. It is a piece that would explode in the art world in 2017, and simultaneously develop an ardent following far beyond the walls of the high-end galleries and art festivals where it would be screened across the globe. It was this ability to converge high and low, fine art and popular culture that, in the hands of Arthur Jafa and his collaborators at the production collective TNEG, "broke the Internet" in the summer of 2017.

When he arrived at the doorstep of my temporary Dalston digs, he was the same person I had met the previous year, humble and gifted and in a state of disbelief that so much had happened in one short year. I was equally humbled and in disbelief—humbled to have been fortunate enough to know him at this critical point in his career, and equally fortunate to share an anticipation of what he has since described as "a tsunami" of work by Black artists that was poised to take the world by storm.

He had arrived predictably late. It was just after midnight and it was only because we were ridiculously jet-lagged that we were even awake. I had arrived several days earlier and was housesitting for a friend who was on vacation. My friend Saidiya had arrived the

day before from New York and decided to stay with me because she said her hotel made her feel she was living in a dorm. She and AJ were old friends, and it was she who had introduced us and introduced me to his work.

While AJ is well known for his troubled relationship to punctuality, this time the delay was for good reason. He'd been working alongside his TNEG collaborators around the clock doing final edits on a Jay-Z video that had dropped only hours before. He then hopped on a redeye from LA for a series of events linked to his own show in London. After over thirty years of producing scores of critically acclaimed works, his first solo exhibition had finally opened in none other than the storied halls of the Serpentine Galleries.

When Jay-Z's music video, 4:44, dropped earlier that day on his proprietary music-streaming platform Tidal, the Internet momentarily crashed as users inundated the system attempting to view it. Needless to say, Jay-Z is a master of promotion and timing, and his commercial savvy is nothing less than legendary. But this carefully cultivated anticipation was stoked as well by both the success of *Love Is the Message* and Jafa's reputation as a fine artist with street credibility and a gift for visualizing the beauty and grit of the Black experience.

Things had come full circle in the summer of 2017, and I mean that quite literally. It truly felt as if the day 4:44 broke the Internet was the culmination of a year of encounters that set me on a path to this book, and to a series of insights and observations about a phenomenon I have come to describe as a *Black gaze.*

. . .

It's a fact I'll happily cop to for the record: I am unapologetically
enthralled by the everyday photographs created by Black
communities. Photographs speak in unique ways to our
circumstances. They talk back to power, and they talk around
and in between its silences and absences. Yet, while some of the
most compelling images of the African American experience have
historically been still photographs (the raised fists of Tommie
Smith and John Carlos at the 1968 Olympics, Martin Luther King Jr.
addressing the masses assembled at the 1963 March on Washington,
dignified and defiant portraits of Frederick Douglass and Harriet
Tubman, marshals escorting Ruby Bridges to school, or Black
protesters being attacked by police dogs), I am struck by the fact
that the end of the twentieth century and the beginning of the
twenty-first have ushered in a profound shift in the image-making
practices of Black communities.

It is to the moving image, rather than still photography, that our
communities now turn to capture the increasing precarity of
Black life—that is, the precarious circumstances of Black people
and the increasing prevalence of premature Black death. And it
is through digital rather than analog technologies that we now
document, archive, and disseminate the mounting threats to
Black communities. But we are also using these technologies to
catalogue our everyday lives, the beauty of our bodies, our naïve
and bold aspirations, and our hopes and dreams for changing our
current reality. Our repository is no longer handmade albums
or scrapbooks; it is now Facebook, YouTube, Instagram, (Black)
Twitter, and numerous other self-curated online collections made
by ordinary people seeking to capture the vicissitudes of Black

life. It is this burgeoning archive of amateur digital imagery that recurs repeatedly and with devastating effect in Arthur Jafa's most impactful works. And they resurface yet again in *4:44*.

Like *4:44*, Jafa's most captivating works (among others, *Dreams Are Colder Than Death*; *Love Is the Message, The Message Is Death*; *Apex*; and *The White Album*) are films created from precisely this everyday archive of Black precarity. He spent years collecting videos and images from Facebook, Twitter, YouTube, and numerous other sources made by Black communities to document the highs and lows of their day-to-day struggles. He stockpiled them as files he accumulated on the mobile second-brain repository that is the desktop he drags from pillar to post across the globe, and which he dragged into my borrowed Dalston flat in the summer of 2017. My first encounter with AJ in New York in August 2016 and our encounter in London in July 2017 are the double-sided, swinging doors that unlocked an ongoing encounter with a Black gaze.

. . .

By all accounts, we find ourselves in the midst of a Black artistic renaissance. Power brokers like the dynamic duo known as The Carters (aka Jay-Z and his partner in all things musical, Queen Beyoncé), Rihanna, Spike Lee, Shonda Rhimes, Ava Duvernay, Barry Jenkins, Steve McQueen, Oprah Winfrey, and Tyler Perry are some of the many cultural and artistic icons who are reshaping the circulation of Black culture on a global scale. Their influence cannot be explained by any single factor, for they come from a diversity of backgrounds, generations, and media. They are influencers who hail from the US, the UK, the Caribbean, and the African continent, and their impact is felt across multiple media, from music to dance, criticism, video, film, artwork, fashion, and design.

This is certainly not the first time that Black artists have made a profound impact on the cultural politics of this nation or others across the globe; they are in fact part of a long and ongoing tradition of Black artistic intervention in the culture and politics of societies across the African Diaspora. In the US, the roots of this particular artistic outpouring can be traced back to its predecessors in the Harlem Renaissance of the 1920s and the Black Arts Movement of the 1960s and 1970s. Both, in their own way, heralded the emergence of politically motivated Black poets, writers, artists, and musicians whose creative practices were intended as an affirmation of Black aesthetics, culture, and consciousness.

This admittedly partial list of contemporary Black cultural and artistic icons of the late twentieth and early twenty-first centuries must, in this way, be seen as indebted to and extending earlier Black creative formations, albeit with a decided difference of magnitude. For, unlike with their predecessors in the Harlem Renaissance and the Black Arts Movement in the US, the impact of the current group is structural—it is the power of creative genius combined with corporate ownership (Jay-Z's Tidal and Oprah Winfrey's corporate conglomerate being two prime examples) and its accompanying cultural and economic capital.

The ascent of the current group of Black artist-entrepreneurs has been enabled by the technological advances of the Internet and social media, which have allowed individual artists direct access to modes of production, marketing, and most significantly, to media outlets and audiences that were previously out of reach except by way of largely white gatekeepers in the music, television, film, and publishing industries. Contemporary Black artists are not only able to circumvent these gatekeepers; they are, in turn, creating new outlets for themselves and other emerging artists.[1]

But while contemporary Black-produced popular culture brings broader visibility to Black life and history, more often than not its emphasis centers on the *depiction* of Black people and communities, while maintaining existing limitations of traditional ways of narrating the Black experience. Although it often proceeds from a Black point of view, its major accomplishment is frequently that and that alone. It adds an additional perspective—a Black perspective—but it doesn't necessarily challenge the fundamental premise of the existing framework for viewing blackness. It does not challenge the fundamental disparity that defines the dominant viewing practice: the fact that blackness is the elsewhere (or nowhere) of whiteness.

In this approach to Black visuality, while blackness is now seen (i.e., made visible to a wider audience), it is not necessarily something to be felt. Much too often, Black life is rendered in ways that allow it to be engaged at a safe distance or viewed at arm's length through a lens of pity, sympathy, or concern. It is a temporary point of connection, visited and left behind in the face of an inevitable return to the comfort and comforting perspective of self and "home."

My point here is not that there was no innovative Black art that preceded or informed the current moment—very much to the contrary. My focus is on how certain contemporary artists are building on these innovations, not only in film and popular culture where their impact is certainly manifest, but more notably in the field of fine art. Here the radical question they are posing is: rather than looking *at* Black people, rather than simply multiplying the representation of Black folks, what would it mean to *see oneself through* the complex positionality that is blackness—and work through its implications on and for oneself?

Alongside the aforementioned explosion of work by Black artists in mainstream popular culture, a group of Black fine artists are initiating a different and, I would argue, more transformative cultural, aesthetic, and indeed, political shift that is drawing unprecedented attention. They are shifting the very nature of our interactions with the visual through their creation and quite literal curation of a distinctively *Black* gaze. It is a gaze that is energizing and infusing Black popular culture in striking and unorthodox ways. Neither a depiction of Black folks or Black culture, it is a gaze that forces viewers to engage blackness from a different and discomforting vantage point.

This growing and increasingly influential cohort of Black artists are choosing to look after, care for, and reclaim an uncomfortable Black visual archive that makes audiences work through and toward new ways of encountering the precarity of Black life. Their artistic practices mobilize Black precarity as a creative force of affirmation that cannot simply be seen or viewed. It is a Black gaze that shifts the optics of "looking at" to a politics of *looking with, through, and alongside another*. It is a gaze that requires effort and exertion—a statement that returns me to "the video that broke the Internet."

<center>. . .</center>

A silent serenade between Jay-Z and Beyoncé live on stage: singing, serenading, flirting. It's sassy. It's sensual. She teases, he taunts, they both tantalize. She loves it, he clearly loves her for it, and we are captivated by their exchange of smiles and glances, and her twirls around and around him layered over the sweet simmering whisper of Al Green cooing his love-song-cum-lullaby, "Judy."

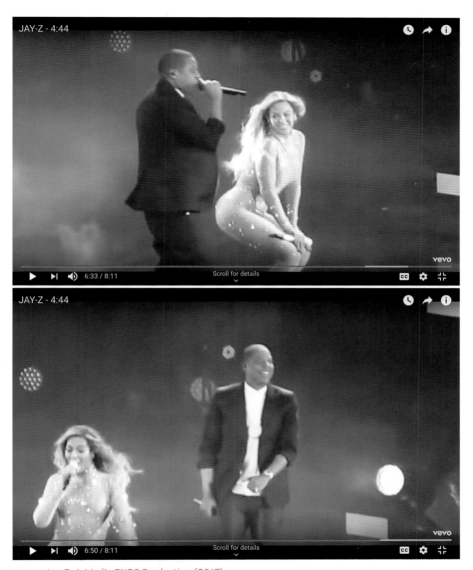

Jay-Z, 4:44, dir. TNEG Production (2017)

The footage is grainy, but its texture has nothing to do with age. Its grain comes from its visual frequency, which filmmakers, editors, and cinematographers commonly refer to as frame rate. In this case, it is an intentionally slowed frame rate that reveals the tender relations of both the scene and its subjects. This grainy, slow-motion clip gives an intimate framing to one of the most public Black couples on the planet.

The sequence spans only a few seconds (though it feels far longer), then erupts to inject live concert audio of call and response with Queen Bey stoking the audience's collective refrain. But this tantalizing scene is preceded by shattering footage: film footage culled from *Birth of a Nation* toggles between cellphone footage of a Black man being beaten by a scrum of white police, and CCTV footage showing a car mowing down Black bystanders in a parking lot. Interwoven amongst them is additional footage: cellphone video captured by ordinary people of street scenes, parties, and dancers, drawn from an endless archive of found footage posted on various online sites.

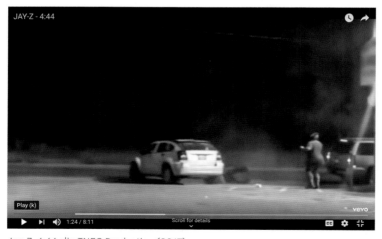

Jay-Z, 4:44, dir. TNEG Production (2017)

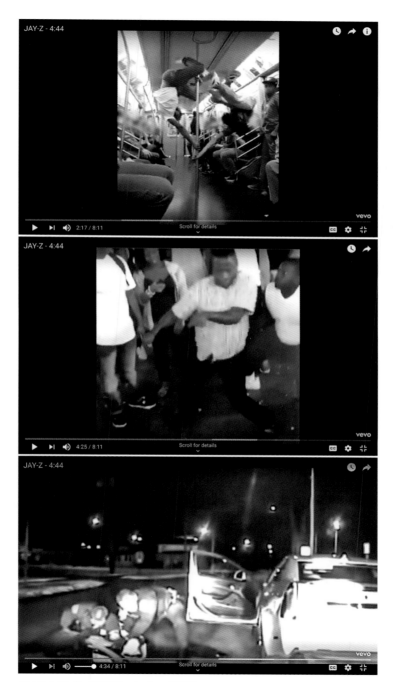

Jay-Z, 4:44, dir. TNEG Production (2017)

A different cellphone video captures a prepubescent boy belting out the opening lines of Nina Simone's signature rendition of "Feeling Good" with the vibrato of a sixty-something blues singer from the backseat of a moving vehicle. It transitions to hyperpixelated footage of Eartha Kitt mid-soliloquy, waxing characteristically defiant, poetic, and dismissive of love and relationships. Silent portraits of two Black feminist theorists flicker briefly between these and other unlikely scenes, leaving unanswered questions in their lingering shadows. And a bleach-blond Black man filmed against a blindingly white background bears witness to hearing the voice of the Almighty speak to him in the moment of his temporary death after taking a bullet. He recounts his reflections with the wisdom of a shaman and the charm of a playa.

Jay-Z, 4:44, dir. TNEG Production (2017)

The video for Jay-Z's 4:44 (2017) is chock full of love and loss, beauty and brutality, Black pleasure and Black precarity. While clearly commissioned as a music video, it, like videos by other artists engaged in this book, challenges the definition of what actually constitutes this genre in ways that query whether it should in fact be considered some other hybrid form. Although produced as a visual and commercial vehicle for the song, the video is in no way beholden to it. It is a work that inverts the relationship between image and song by transforming the music into a vehicle for the astonishing montage of images created by Jafa and the TNEG collective. Indeed, the video itself interrupts Jay-Z's penetrating track multiple times, disrupting it to insert its own structure of commentary, testimony, music, and performances throughout. In the end, it coalesces around a series of visual duets that intertwine pleasure and despair and juxtapose the extremities of Black life in the twenty-first century. We see these extremities through the intentionally grainy frame of Jafa's cinematic lens. It is a grain that emerges when the diminutive frame of cellphone video is expanded to a much larger screen.

But it's also a grain that we feel as much as we see it. We feel the rough, unfocused grain produced by zooming in for a hyper-close-up on cell or CCTV footage of a beating or a drive-by. We feel the grain of a zoom-in that allows us to appreciate the artistry of an impromptu subway performance, an improvised dance at a party, or a backseat solo performance. We feel it in the halo-like blur that results when a master cinematographer shows us the power of the everyday visualizing practices of ordinary Black folks' "amateur" videos. They are videos that allow us to see ourselves as discerning and uncompromising witnesses who adamantly refuse to look away.

4:44 whiplashes us between giggles and gasps, winces and sighs,
yet what weaves the emotional extremes of this eight-minute
collage together and connects the mosaic of clips it gathers to
the lyrical apology Jay-Z professes in the song is a breathtaking
physical duet created by the coordinated sinews of muscle and
flesh of two extraordinary movement artists: acclaimed flex dancer
Storyboard P and MacArthur award-winner Okwui Okpokwasili.
The two did not rehearse prior to the take included in the video;
they were asked instead to dance simultaneously in tandem. What
emerges is an organic symbiosis and a spontaneous interaction.
They never touch, but there is contact nonetheless. The correlation
of their bodies is something more than a dance and more than
a choreography. It is a corporeal negotiation of intimacy and
distance, tension, tenderness, and rage.

Jay-Z, 4:44, dir. TNEG Production (2017)

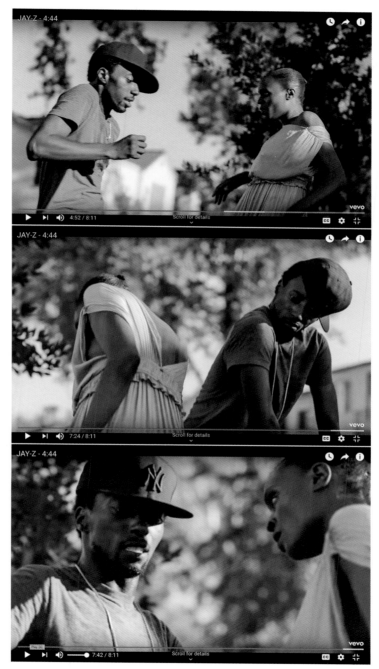

Jay-Z, 4:44, dir. TNEG Production (2017)

Storyboard and Okpokwasili's fleshly improvisation mirrors the emotional apology that is the dominating lyric of 4:44. Placed in the context of the larger stream of visual duets it gathers, the video offers a very different kind of mirror. It is a mirror on Black sociality. It is a mirror that reflects and refracts an uncomfortable portrait of Black life in the US at a moment when its most stunning and honest visualizations are those that twin the joys of the Black quotidian with the pain of Black precarity.

The video captures Okpokwasili running languidly, then fluidly, at times seeming as if she is about to launch into flight. But most of the time she remains in place, vibrating intensely. Her body ripples; her neck rolls; she appears to rotate on her own axis. She undulates at a distance from Storyboard, then grazes him closely. She turns away, then faces off in a confrontation that pivots back and forth between aggression and intimacy, conflict and vulnerability, apprehension and deep affection. As Storyboard passes behind, alongside, or in front of her, the motion of his body suspends time and seems to deny the physics of the corporeal relation between skeleton and flesh. He moves neither vertically nor horizontally; his body flows like a viscous material that mediates solid and liquid. *He flows. She flows.* And as I will argue in the chapters that follow, Black flow is creating a radical Black gaze. Or put another way, *we flow* . . .

■ ▪ ▪

Watching 4:44 isn't easy. It doesn't tell a story. It narrates neither the lyric of the song, nor the sexy hip-hop life of bubbles and bling. You have to work to understand the connections between its various clips and sequences. I get goose bumps listening to

the vibrato of that young boy singing in the backseat of a car. It's chilling to watch a scene of a Black boy on an auction block culled from *Birth of a Nation*. It hurts to watch video footage of police officers' relentless abuse of a black man spliced so seamlessly into clips of parties and concerts. And it's harrowing to watch a body bounce off the hood of a moving car careening through a parking lot to intentionally hit a bystander. But *4:44* is a video we both want and need to see. Its beauty and its power is that it requires us to be present. Watching it requires us to cycle through discomfort in order to appreciate its moments of sublime reverie—reverie in Black love, in Black survival, and in a future we were never promised, yet claim and cling to vigorously and vociferously. It's a discomforting, aspirational, defiant gaze. It is a *Black gaze*.

This book sketches the contours of this emergent Black gaze, focusing on a group of artists whose creative practice produces radical forms of witnessing that reject traditional ways of seeing blackness—ways of seeing that historically depict blackness only in a subordinate relation to whiteness. What defines and unites their divergent practices is their ability to make audiences *work*. They refuse to create spectators, as it is neither easy nor indeed possible to passively consume their art. Their work requires *labor*—the labor of discomfort, feeling, positioning, and repositioning—and solicits visceral responses to the visualization of Black precarity.

In *Image Matters* (2012), I described a related form of labor as central to the concept of haptic images. I defined haptic images as images that move us both through our physical encounters with them and through the affective investments with which we imbue them. Haptic images "triangulate, imbricate, and implicate their viewers, their subjects, and their makers" through multisensory interactions that comprise the act of viewing them.[2] In the field of film and video, Laura U. Marks articulates her own conception

of haptic images to develop the idea of haptic visuality, which, she writes, "implies making oneself vulnerable to the image, reversing the relation of mastery that characterizes optical viewing."[3]

Building on the idea of haptic images and haptic visuality, this book asks us to consider what kind of work these artists ask us to do and what kind of labor it requires of us. Posing these questions means asking what is at stake in their work, as well as what are the stakes of creating this particular kind of art. My answer is that these artworks demand a different kind of response, or more precisely, a particular kind of *responsiveness*. They insist that we actively inhabit a state ranging from disorientation and unease to implication and vulnerability and that we work through these responses to come out somewhere new and important. They demand a recognition that we are implicated in the precarity of Black life in the contemporary moment. In embracing this implication, we are faced with a choice: *act or be complicit*. It is a recognition that requires us to develop a different way of engaging art by way of a Black gaze that mandates our participation in and interaction with the social and political questions these works raise, in ways that leave us vulnerable to their effects and better off for it.

. . .

A Black Gaze **is composed of seven verses** of differing lengths and diverging tones that bridge a lyrical and musical understanding of a verse. A verse is at once a visual structure (a stanza), a form of metrical writing (poetry), and a section of a song that tells a story or is followed by a chorus. The lyrical structure of the verses that follow offers a free-flowing and open-ended meditation on the musical/poetic dimensions of the artworks explored in the book, each of which exceeds reduction to a particular artistic

genre or a traditional form of analysis. Each verse contains a series of keywords and definitions which, like a stanza, are intended to function visually as images and, at the same time, create a kind of toolkit for understanding how a Black gaze unfolds in the work of each artist. The lyrical vocabulary that shapes these verses is part of my broader commitment to understanding visual culture through its entanglement with sound, and highlighting the centrality of sonic and visual frequency to the work of Black contemporary artists.

This book tells the story of the indelible impression these artists and their work have made on my thinking, and the profound insights they provide into understanding Black sociality in the twenty-first century. It charts the meandering path that led me into the art world through a chain of encounters with an unusual group of artists at different stages of their careers. They are encounters that resulted from my own restless travel as an itinerate academic who has spent much of her life researching the history of racial formation in Europe, and my need as a theorist of Black visual cultures to understand the vicious attacks on Black bodies I was witnessing at home and abroad and struggling to address in my teaching and writing.

Living through COVID-19 pandemic, such peripatetic travel has certainly come to feel like a lost dream. It feels like an artifact from a simpler, bygone era or a childhood memory of riding your bike without a care while waving your arms in the air. But my travels to far-flung locations to witness the power of these works, as well as their impact on different audiences in contexts that brought together Black artists and thinkers in unprecedented configurations, were neither a dream nor a luxury—they were a gift. Traveling to multiple sites around the globe to see the work of Black fine artists finally receiving recognition at major art

festivals, museums, and galleries was something that would have seemed unlikely, if not impossible just a few years before. It was an opportunity I moved heaven and earth to take advantage of because these precious occasions created a rare space for sustained conversations among Black artists, writers, critics, and theorists that were life-sustaining for us all.

Here I find it important to emphasize that this project did not begin with an intention to write about art. It was not initiated as a research project or a theoretical exercise; it became that on the basis of powerful and often quite serendipitous encounters with artists and their work. This book emerged from the experience of engaging with art and artists that addressed our circumstances more deeply and more powerfully than any of the texts I was reading. They are artists creating new ways of seeing—and seeing blackness, in particular—differently. The insights of these generous and complicated artists propelled me onto and through this journey, and gave me a deep understanding of both what art can do and how it does it at its best.

The verses that follow explore the emergence of a Black gaze in the work of a diverse selection of artists that includes filmmakers Arthur Jafa, Kahlil Joseph, and Jenn Nkiru; photographers Dawoud Bey and Deana Lawson; and multimedia artists Okwui Okpokwasili, Simone Leigh, and Luke Willis Thompson. Some are already influential, while the influence of others has yet to be revealed. They represent the "tsunami" that Jafa predicted is about to unfold. Like the video that broke the Internet, like Storyboard P and Okwui Okpokwasili's stunning improvisation, like the "Showtime!" subway dancers captured in stop-motion levitation in this same video—these artists are creating images that *flow*. They are images that resuscitate and revalue the historical and contemporary archive of Black life in radical ways and with radical possibilities for imagining a different kind of Black futurity.

A *Black Gaze* departs in significant ways from the notion of the
gaze popularized within the field of cinema studies, most notably
because it is not limited to film or filmmaking. It broadens
this concept by exploring a Black gaze not only in lens-based
art forms like film and photography but in a range of artistic
practices that include movement and performance, sculpture,
sound installations, and music video. A Black gaze is a structure
of visual engagement that implicitly and explicitly understands
blackness as neither singular nor a singularity; it embraces instead
the multiplicity of blacknesses these artists simultaneously
grapple with and personify. Here my choice of the indefinite
article is intentional, for I am proposing that we think about
a Black gaze (rather than *the* Black gaze) and understand it as
both multiple and polyvalent. It is at once a critical framework, a
reading apparatus, a term that describes an artist's practice, and a
spectatorial mediation that demands particularly active modes of
watching, listening, and witnessing.[4]

Rather than setting forth a hard and fast definition of a Black gaze
at the outset, I endeavor instead to activate it in different ways in
each verse, allowing it to unfold in its full multiplicity through the
artworks in which it is enacted by individual artists. To begin with
a singular definition of a Black gaze would necessarily truncate and
fix it in ways that do a disservice to the kinds of work it does in the
hands of these exceptionally talented makers. Yet I do find it useful
to take as a point of departure a frequently overlooked articulation
of this concept offered by a theorist whose work is frequently
cited as foundational for theorizing the gaze: Jacques Lacan. It is
a formulation that resonates strongly with the idea of a Black gaze
that I see in the work of the artists explored in this book:

> The function of the picture—in relation to the person to whom the painter, literally, offers his picture to be seen—has a relation with the gaze. This relation is not, as it might at first seem, that of being a trap for the gaze.... I think there is a relation with the gaze of the spectator, but that it is more complex. The painter gives something to the person who must stand in front of his painting which, in part, at least, of the painting, might be summed up thus—*You want to see? Well, take a look at this!* He gives something for the eye to feed on, but he invites the person to whom this picture is presented to lay down his gaze there as one lays down his weapons.... Something is given not so much to the gaze as to the eye, something that involves the abandonment, the *laying down*, of the gaze.[5]

This more capacious idea of a gaze opens up a different set of possibilities for understanding other potentialities of a Black gaze. It unleashes some of the multiple meanings of the gaze that are impossible to imagine when it is understood as always already tethered to a prior injury or a structure of dominance. Rather than trying to invent a new term for the transformative practices of witnessing and implication created by the artists engaged in these pages, rather than reducing them to alternative forms of "looking," I choose instead to embrace the radical power of their work as constituting *a Black gaze*. It is a gaze that sets in motion a choreography of practices that are constantly up for grabs.[6]

It is in the spirit of this open-ended choreography that I propose the idea of a Black gaze, while at the same time acknowledging that it is a challenging shift in our understanding of what looking and seeing mean at this pivotal historical moment. Exploring the contradictions between our current inundation with images of precarious Black life and seemingly disposable Black bodies on the one hand, and the equally striking ascendance of Black aesthetics both in popular culture and the art world on the other, the verses

that follow summon readers to confront the deeply entrenched forms of racism and white supremacy we face at this urgent conjuncture. This book should be read as a provocation to reckon with the paradox of being Black in the twenty-first century that, as Christina Sharpe explains, requires us "to recognize the ways that we are constituted through and by continued vulnerability to overwhelming force though not only known to ourselves and to each other by that force."[7]

Recognizing that Black life is constituted through vulnerability to the overwhelming force of anti-blackness and white supremacy, and yet not capitulating to *only* be known by these same forces is a tall order. It necessitates that we refuse to be overwhelmed by historical and contemporary forces of negation that have shaped the lives of Black people since the advent of modernity. But the fact that we have actually developed these skills and capacities is both the fundamental point of origin for the idea of a Black gaze and an affirmation that it does indeed exist. The creativity, ingenuity, cunning, and courage that allow us to acknowledge the forces that would define us, and yet not succumb to that definition, is the modus operandi of a Black gaze.

In the end, I realize that a Black gaze might seem a fundamental contradiction in terms that some will be unwilling to accept. Steeped as it is in white male desire as the privileged perspective of viewing, and lodged so profoundly in the logics of the plantation, one might understandably ask (as did early readers of the book) whether the concept of the gaze is capable of doing the work I am proposing. Indeed, Jafa himself has maintained that "If you point a camera at a Black person, on a psychoanalytical level it functions as a White gaze. It therefore triggers a whole set of survival modalities that Black Americans have. It doesn't matter if a Black person is behind the camera or not, because the camera

itself functions as an instrument of the White gaze."[8] While it may seem as if I want to have it both ways, I would still argue that Jafa's statement is accurate and yet, at the same time, does not preclude the emergence of a Black gaze, even in his own work. And hopefully, the verses that follow will bear out my contention.

Here again, I must cop to the fact that I've been drawn to counterintuitive concepts for a long time, as they have always offered me a powerful source of inspiration. Counterintuition requires us to think beyond our comfort zone, to think oppositions in tandem, and to think them in a different grammar—not the grammar of the declarative ("this is"), but in the grammar of my favorite tense: the subjunctive tense of the future real conditional. It is not a provisional tense, but one premised on the realization of a different future. It is the tense of "as if." It is an intentional deployment of aspiration that strives toward a multitude of possibilities. The future real conditional or *that which will have had to happen* is proceeding "as if." It proceeds "as if" our aspirations were being or had already been realized. It is a radical provocation to *see* blackness differently and, in so doing, to create a path to *living* blackness differently—not in the future, but now.

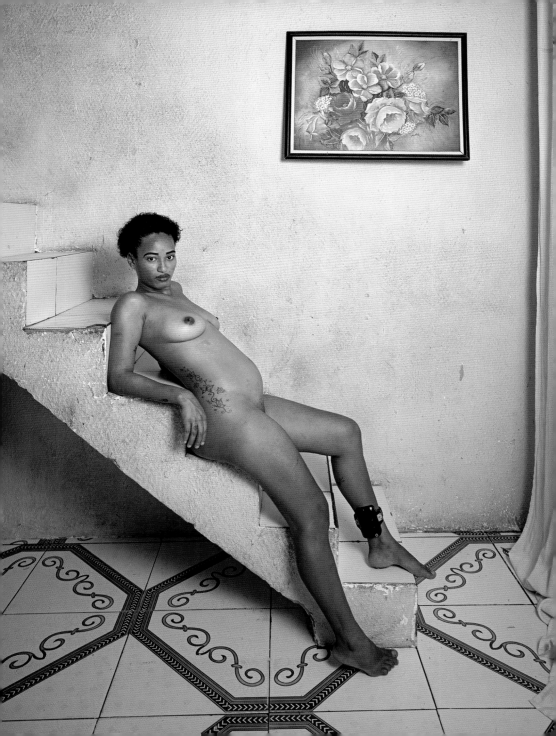

The Intimacy of Strangers

I had made only one studio visit prior to my arrival at Deana Lawson's Brooklyn studio on a blustery August afternoon. Truth be told, I'm still not quite sure what a studio visit is supposed to look like, and on that day, I was pretty nervous about the fact that the artist herself would be there watching me and my curious way of writing. It's a method of writing Lawson herself gave me words for when she invited me to visit, describing it as "a studio practice of writing."

Rather than writing *about* artworks, I spend most of my time at exhibitions and galleries sitting with and writing *to* them. I write to them about the feelings they solicit, the forms of discomfort they evoke, the emotional work they require and often demand, and the potentially transformative effects they have when we allow ourselves to inhabit those feelings and responses. So, as I said, I was nervous about what felt like my very first official "studio visit." My fears turned out to be needless, for my visit to the studio of one of the most daring photographers of our current moment

was nothing less than exhilarating. Much to my surprise, when I checked my email the next morning, I found she had written me a thank-you note, when of course, it was I who really needed to thank her. But I had to chuckle at her opening lines.

> **Thank you for taking the time to visit the studio today. It was my first meeting where the visitor wrote in silence "on the floor" at the beginning. It was nice to observe your writing/thinking process.**

Seated cross-legged on the floor is my go-to position for writing to art. There was a time when I was self-conscious about it. But after years of yielding to gravity to create a personal cone of silence so I could take in the full impact of art in spaces that frequently militate against the forms of lingering and observing required to truly grapple with work that is difficult to come to grips with in the space of a gallery or museum, I have no compunction about sliding down a wall and claiming the undervalued real estate of a gallery floor.

Writing to artwork from the floor of a gallery (or, in this case, an artist's studio) minimizes you as a viewer and maximizes the work itself. Looking up at it both breaks up and breaks down some of the traditional dynamics of spectatorship and visual mastery. And when the subject of that art is Black folks, challenging the dynamics of spectatorship and visual mastery is an extremely important intervention.

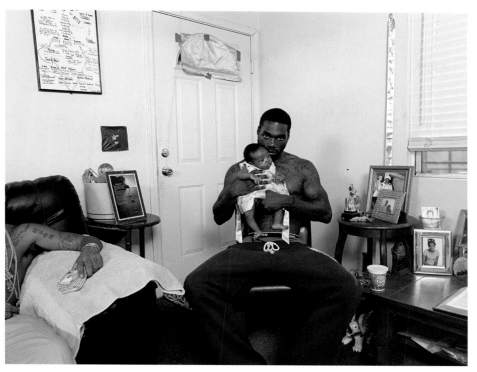

Deana Lawson, *Sons of Cush* (2016)

A muscular young Black man paired with a partial view of a companion who shares the space seated next to him on a couch. They occupy a tiny front room packed with furnishings, objects, and images that fill the compact space of a home that seems almost too small for its occupants. One man cradles an infant in his oversized hands; the other flashes an oversized wad of cash in an equally oversized hand.

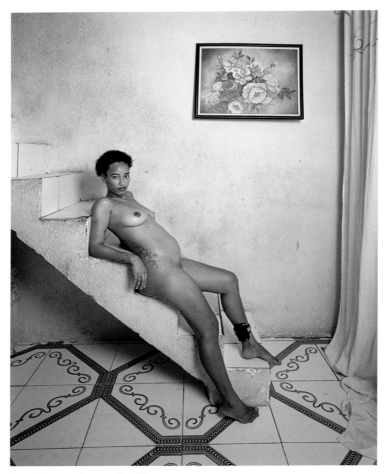

Deana Lawson, *Daenare* (2019)

A nude, bronze-skinned, Brazilian woman lies in the classic repose of a nineteenth-century odalisque. She drapes herself over salmon-colored concrete steps against the backdrop of identically colored walls. Snaking from waist to thigh is a tattoo that guides our gaze past a nascent baby-bump and down her long legs to rest on an ankle shackled by a strap and the unmistakable metal box of an electronic monitoring device.

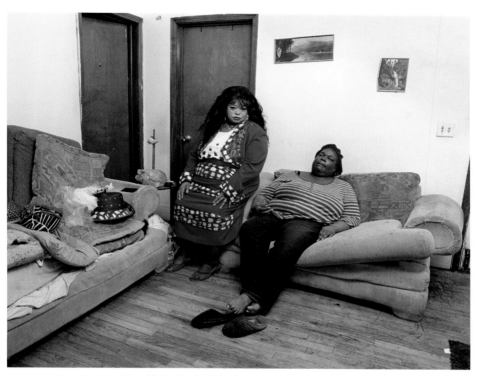

Deana Lawson, *Taneisha's Gravity* (2019)

*An older Black woman in a cherry red suit perches on the arm of one
of two massive and clearly over-loved couches in Rochester, New York.
On the couch to her right sits the matching accessory to her fabulous
ensemble: an extravagant red hat befitting a treasured matriarch or
dedicated church lady. Seated to her left and sharing the couch on which
she perches, her daughter nods off peacefully beside her.*

These were some of the images that hung on the walls of Lawson's studio on the day of my visit. But before I sat and wrote to them, they insisted that I walk with them. They are photos that beckon us to travel with and alongside them. They cannot be engaged passively; they demand an encounter. As I stood before them, as I walked and lingered in, between and among them, I felt *them* watching *me*—taking me in and taking me into the spaces of their homes through the stairways, hallways, and rooms they inhabited and traversed. They are images that beckon you into their places of work in the club, on the street, or somewhere else altogether. Lawson's photographs draw us into a world of strangers to whom we feel intimately connected.

Perhaps it's their scale that makes them register so intensely. The photographs Lawson had on display were huge. She told me she had been encouraged by Los Angeles artist, activist, and founder of the Underground Museum, Noah Davis, to "go big," and that his words had inspired her to expand the size of her prints from the typical scale of framed gallery prints to expansive tableaus. In doing so she transforms the Black subjects captured in their frames into life-sized simulacra that force us to meet them as equals. Writing to her images from the floor of her studio, encountering them from the bottom up, seated at their feet, gave me a necessary sense of humility—humility in relation to Black men and women whose unrelenting gazes ricocheted palpably around the room. While Lawson and I were the only people in the studio, the intensity of their presence made it feel as if we were in the middle of a very crowded space.

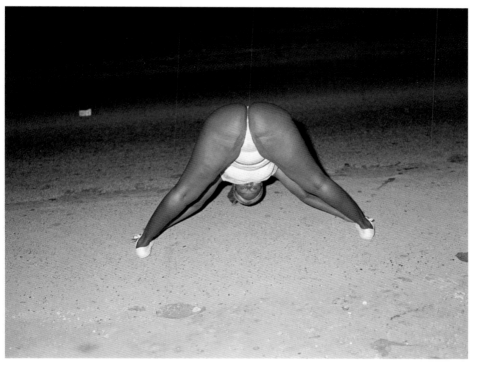

Deana Lawson, *White Spider* (2019)

A full-figured Black woman in a body suit and sleeveless mesh top stands in a deserted location. The scene is lit for the camera yet devoid of any visible lighting save for that of an inexplicable object in the background. It is a setting so barren it resembles the surface of the moon. In this eerie lunar landscape, she poses in an upside-down spread-eagle revealing her wide brown bottom. Grasping her ankles, she moons us while looking straight into the camera.

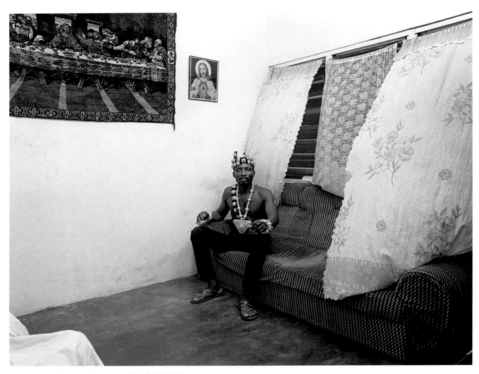

Deana Lawson, *Chief* (2019)

A bare-chested Black man poses regally, seated on a worn couch flanked by billowing curtains swept into the room by a night breeze from open windows. The camera focuses our gaze on his gold adornments: bracelets, an amulet, and a crown—tribal regalia he wears with the posture of African royalty. Indiscernible to the viewer in the lower left corner is a couch on which an elderly woman sleeps through the shot.

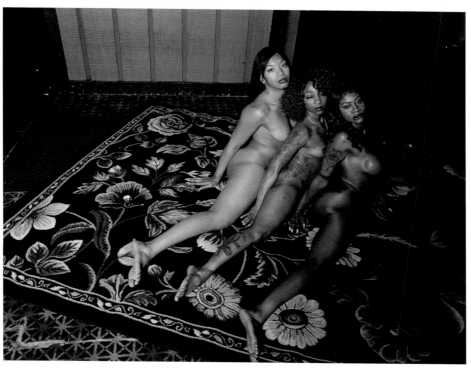

Deana Lawson, *Axis* (2019)

*A trio of nude Black women—café au lait, chocolate, and ebony—splay
out in tight formation, embracing each other bosom to back and
groin to bottom on a carpeted floor. Posing in full splits, backs curved,
chins raised and looking over their shoulders directly into the camera,
their assemblage resounds like the ascending notes of a musical scale:
do, re, mi . . .*

Lawson's giant prints meet you eye-to-eye. To view them is to engage in a face-to-face dialogue and be challenged to withstand the force of their penetrating stares. Eschewing the historically elevating function of portraiture to cast its subjects as superior to others, Lawson's images render her subjects as equals. They are photographs that invert the normal rules of spectatorship and spectacularity. Rather than viewing them, we are viewed by these subjects instead. Rather than scrutinizing them, they scrutinize us, and we are captured in an inscrutable and inscrutably powerful Black gaze.

Over the course of writing the verses that comprise this book, I've spoken to a number of artists about the idea of a Black gaze and how I see it emerging in their work. A Black gaze is not a concept they immediately embrace. The moment I utter the words "Black gaze," it's all too frequently met with a short and sometimes awkward pause. I understand it as both a pause of reflection and a pause of suspicion. It is a pause that usually leads to a head tilting left or right, followed by a sidelong glance. It's a look I translate into an equation: *Black + gaze = WTH?!*

I understand the reasons for such initially perplexed responses among the artists I've spoken with. They are individuals steeped in the craft of their artistic practice, but also in the vocabulary and discourse of scholars and critics who write about art and theorize Black culture. For them, like many readers of this book, the idea of tethering blackness to the concept of the gaze is a combination of terms that begs the question of whether a Black gaze is an attempt to invert a structure of visual dominance or domination for the use of the dispossessed. And if this is not case, at the very least, it raises the question of what, in fact, is its true purchase?

"The gaze" is a weighty term that has emerged most forcefully and been appropriated most widely in the field of cinema studies, and in feminist film theory in particular. It is a term most frequently cited to articulate the structure of visual spectatorship and pleasurable looking; specifically, who gets looked at, how, and at whose expense. Commonly understood as a gendered dynamic of spectatorship centered on voyeuristic or narcissistic pleasure in looking, the classic definition of "the gaze" (articulated most notably by film theorist Laura Mulvey) defined the white male viewer as the "bearer of the look" and the white woman as an object "to-be-looked-at." This widely embraced understanding of the gaze is invoked well beyond discussions of screen culture as a shorthand reference to a dominating act of looking that domesticates and objectifies women, as well as non-white subjects, to serve the pleasures of a white male spectator.[1] Here the white gaze operates as an abbreviation for a multiplicity of visual structures of dominance (e.g., the racist gaze, the colonial gaze, etc.), and thus represents a site of convergence for multiple critical legacies.[2]

Black cultural critics and film scholars have forcefully challenged the monolithic understanding of the gaze. Black feminist theorist bell hooks begins her foundational essay "The Oppositional Gaze: Black Female Spectators" by stating with characteristic clarity that "the gaze has always been political in my life."[3] Recalling her own childhood, when daring to direct intense looks of scrutiny at adults was interpreted as a challenge to authority, she links this to a longer history of policing Black people's looks and the authority of the gaze that tyrannized enslaved Black communities which carried forward into Jim Crow America and continues to deny Black subjects the right to gaze. But hooks counters that this legacy of policing the gaze had the opposite effect as attempts to control their gaze made Black folks dare to look, while attempts to repress their gazes produced an equally rebellious desire to

look that she defined as "an oppositional gaze." She explains, "By courageously looking, we defiantly declared: 'Not only will I stare. I want my look to change reality.' Even in the worst circumstances of domination, the ability to manipulate one's gaze in the face of structures of domination that would contain it, opens up the possibility of agency" (248).

The oppositional gaze hooks describes is a practice of critical spectatorship through which Black audiences further developed what she calls "interrogating gazes"—gazes that critically question our encounters with mass media and the negative representations of Black life it all too frequently propagated. "We laughed at television shows such as *Our Gang* and *Amos 'n' Andy*, at these white representations of blackness, but we also looked at them critically. Before racial integration, black viewers of movies and television experienced visual pleasure in a context in which looking was also about contestation and confrontation" (249).

In the same essay, hooks highlights film scholar Manthia Diawara's articulation of the possibility of Black agency in wielding the gaze as what he describes as "a resisting black spectator." In his essay "Black Spectatorship: Problems of Identification and Resistance," Diawara asserts that a "black spectator, regardless of gender or sexuality, fails to enjoy the pleasures which are at least available to the white male heterosexual spectator positioned as the subject of the films' discourse," for, in his view, "resisting spectators transform passive identification into active criticism."[4]

While Diawara's and hooks's early articulations of Black critical spectatorship have been formative to my thinking, the concept of a Black gaze that I am proposing departs from their ideas in important ways.[5] My idea of a Black gaze is one that disrupts the equation of a gaze with structures of domination by refusing to reduce its subjects to objects, and refusing to grant mastery or

pleasure to a viewer at the expense of another. As a concept that is not limited to understanding spectatorship solely or specifically in relation to the dynamics of film and film theory, a Black gaze rejects traditional understandings of spectatorship by refusing to allow its subject to be consumed by its viewers.[6] A Black gaze transforms viewers into witnesses and demands a confrontation. In Lawson's work, it is a confrontation with our discomfort in embracing Black life imaged so unapologetically on its own terms. When we participate as active witnesses in this confrontation, the Black gaze we encounter creates complex and contradictory forms of intimacy.

A nude woman shackled to the surveillance of police.

An adult daughter unable to stay awake in a photo.

Wads of cash that suggest alternative ways of getting by.

Bared breasts and bottoms displayed in unlikely formations and unlikely places.

The images we have viewed are not easy to look at, but effortless viewing is not Lawson's intent. Her photographs bring us into intimate contact with individuals frequently overlooked as marginal or insignificant—members of working class or impoverished Black and brown communities whose struggles are palpable in these images. Unlike the typically passive dynamic between viewers and traditional portraits, these are images that stage an eye-to-eye reckoning that creates forms of intimacy that are not about pity or identification. Neither voyeuristic nor narcissistic, they stage encounters that require work.

We must work to confront our resistance to seeing flawed but beautiful bodies of Black women who refuse to be shamed as they display themselves publicly with dignity and purpose. These images capture women posed in striking geometrical shapes that accentuate the elasticity of flexible bodies. They are photos that echo the long history of Black women's contortions to sustain families and communities against all odds. Lawson's photographs create equally complex imaginings of Black men. They are men who hold babies and partners with passion and pride. They are men who flaunt cash regardless of its source. They are men who wear the regalia of royalty in impoverished settings that lack any indication of grandeur.

Juxtaposing scenes of families gathering casually, assembled in living rooms or on couches after church, with those of nude dancers or fast girls, the photographs make us work to see the relations depicted in and across them not as dissonant, but utterly connected. Lawson does not designate or anoint them with the status of revered or disposable, redeemed or fallen. She does not label or identify her subjects as one or the other. We view them unnamed and ambiguous, and in doing so we are forced as a result to embrace them as our equals. In the process, Lawson creates intimate, yet uncomfortable relationships by twinning the respectable with the profane and celebrating the dialogue between them.

The intimacy Lawson's images conjure is a haunting intimacy among strangers. As viewers we are privy to intimate settings, intimate bodies, and intimate relations between these bodies. Her photographs situate us proximate to subjects we don't know but whom she brings us excruciatingly close to. Her camera's exactingly sharp focus creates a hyperclarity that reveals pores, blemishes, and the gloriously dappled imperfections of Black skin. We see as well the texture of fabrics, surfaces, and objects: the

nap of a rug, the distressed weave of a worn-out couch, the fuzz
on an old slipper, the texture of a wig or a weave, the sheen of a
hat, the weight of a crown. The weft and weave of everyday life
permeate Lawson's images. They capture intimate strangers
rendered so vivid and so familiar that it is impossible to look
away—except perhaps for those schooled to routinely avert their
eyes from ordinary Black folks and the quotidian existence they eke
out across the diaspora.

The Black gaze that emerges in Lawson's work is a gaze that
immerses us in a Black sociality that is simultaneously mundane
and exquisite. They are images that bring together the diverse
spectrum of Black communities across the globe: from Cuba,
Brazil, Haiti, the US, Ghana, and elsewhere. Yet, in Lawson's
hands, these divergent images harmonize. I have somewhat
infamously insisted that certain images require us not simply
to watch or view them, but to listen as well. Lawson's images
of intimate strangers register at a frequency one feels deeply.
They are images that do not speak; they are images that hum.
Sitting on the floor of Lawson's studio, encircled by her life-sized
photographic subjects and struggling to meet their gazes, I felt
the irrepressible rumble of their collective hum.

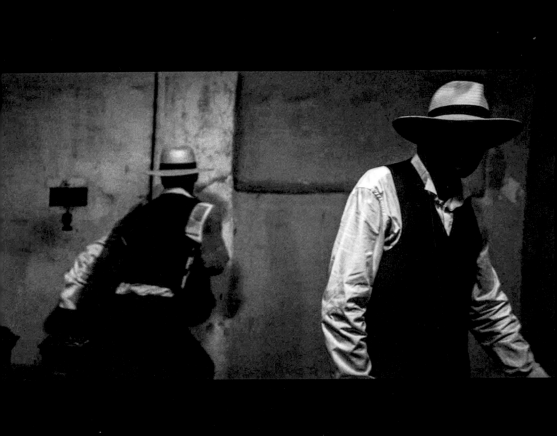

Black (Counter)gravity

I must begin this verse with a confession that will quite possibly offend many people who are near and dear to me: I am no fan of LA. Although I spent five years living in and around the Bay Area, I'm an East Coast girl to the core of my being, and since returning to my native habitat about a decade ago, I find it difficult to make the long trip west to the southern quadrant of the left coast. Every visit makes me feel as if I'm in Neverland, and even as a passionate driver, navigating its special relationship to automobiles always makes my head spin. So when I state the fact that I made an overnight trip to LA from New York (a six-hour flight) only days after arriving in New York from Paris (an eight-hour flight), then hopped back onto a flight to New York the following day (another six-hour flight) for the sole purpose of viewing a single, remarkable installation, you can imagine it had to be for a very good reason.

This mind-numbing sequence of flights transpired in a year when I was living in Paris during a residency that birthed this book. Having endured weeks of the gray, sunless days that plague the City of Lights in winter, the only thing that made the idea of this journey to LA remotely palatable was the promise of warm and

sunny California weather. Much to my disappointment, I had
the misfortune of arriving on the tail end of historic rainstorms
and flooding in Southern California, and was greeted at LAX by a
damp drizzle that only intensified over the course of my twenty-
three-hour visit. So much for a change in the weather!

It was the work of a gifted artist, writer, director, and producer
that propelled me into the grips of Southern California's worst
impersonation of winter weather. Kahlil Joseph's name is widely
recognized in connection with his Emmy-nominated directorial
role in Beyoncé Knowles's 2016 feature-length video, *Lemonade*, in
addition to his much-lauded earlier work creating densely layered
video productions for musical artists such as Kendrick Lamar and
commercial clients like Kenzo Designs or British telecom giant O2.
Yet the LA-based artist is a subtle auteur of sound and image in his
own right, and his talents exceed these more recent, high-profile
commissions. Indeed, the *New Yorker*'s Hilton Als (who is not
known to dish out compliments lightly) dubbed him "a master of
sound" whose work "allows the dialogue and the music in his
movies to drop out and then return at unexpected moments,
creating a sometimes heart-stopping juxtaposition between what
we hear and what we see."[1]

Before diving more deeply into the work of this talented artist, I
need to interject a second confession, or better put, a belated
recognition that adds both texture and context to
the reflections that follow. In the midst of writing
this verse, it dawned on me that I had begun it
and many of the other verses with a reflection
on the weather. The weather has, in one way or
another, shaped many of my encounters with both
the artworks I describe in these pages as well as

weather:
the state of the atmosphere
with respect to wind,
temperature, cloudiness,
moisture, pressure, etc.

to undergo change,
especially discoloration or
disintegration, as the
result of exposure to
atmospheric conditions; to
endure or resist exposure
to the weather.

—Dictionary.com

the artists who created them. Rather than background, it served
as the palpable foreground to many of these encounters. It is also
an atmospheric framing that forces us to see these individuals and
their respective work in a broader social context.

> [T]he weather is the totality of our environments; the weather is the
> total climate; and that climate is anti-black....
>
> it is not the specifics of any one event or set of events... but the
> totality of the environments in which we struggle; the machines in
> which we live; what I am calling the weather....
>
> The weather necessitates changeability and improvisation;
> it is the atmospheric condition of time and place; it produces new
> ecologies.[2]

For Christina Sharpe, the weather is a powerful metaphor for
understanding the atmospheric relations that structure the lives of
Black folks. It is an all-encompassing climate of anti-blackness. It is
a pervasive environment and an atmospheric condition in relation
to which Black folks persistently struggle. And it is our persistent
struggle to survive and, more importantly, to thrive under these
ever-changing conditions (*weathering* the persistent *weather* of
anti-blackness) that Sharpe argues engenders the creation of "new
ecologies"—that is, new relationships between the living, the dead,
and their environments, and alternative organizing principles for
living in relation to one another.

My references to the weather that frames my encounters with artists and their works are made in an effort to not let the social formations of weather that shape and surround our encounters, both literally and figuratively, go unnoticed. These are individuals making art at a moment in time when the weather of anti-blackness is both pervasive and unrelenting. They are making art that engages the precarity of Black life in ways that cast a different light on our communities and provide both devastating insights and inspiring revelations. In doing so, their artistic practice offers us a roadmap to navigating the weather.

I have chosen to make the weather part of this story in an attempt to compose a different account of Black creativity and possibility that focuses on a series of encounters between real people in unlikely places and challenging times. Rather than narrating them objectively or with detachment, I choose instead to enhance their messiness and embellish their complexity. I do this as my way of insisting on an account of these encounters that narrates my memories, responses, and reflections on them, as *fabulations* that mirror the forms of storytelling that lie at the heart of the creative practices of the artists themselves. They are artists and works that insist on fabulating alternative ecologies of Black life.

How do we envision Black futurity in the face of the *weather*? Put another way, how do we imagine Black life beyond the limits of current modes of representation, in the tense of the future real conditional, or *that which will have had to have happened* for Black folks to live unbounded lives? In a historical moment when premature Black death

fabulation:

(definition #1)
The method guiding this writing practice is best described as critical fabulation. "Fabula" denotes the basic elements of story, the building blocks of the narrative. . . . By playing with and rearranging the basic elements of the story, by re-presenting the sequence of events in divergent stories and from contested points of view, I have attempted to jeopardize the status of the event, to displace the received or authorized account, and to imagine what might have happened or might have been said or might have been done.

—Saidiya Hartman, "Venus in Two Acts"

is almost an everyday occurrence (in schools, at home, sitting in your car, being pulled over for a broken tail light, jogging, or simply living in a zip code with few resources and impoverished healthcare facilities) and we are constantly confronted with the disposability of Black life, I want to argue that fabulation offers an important path toward living blackness otherwise.

The central argument of this book is that Black contemporary artists are creating new ways of visualizing Black struggle and transcendence, and in doing so, they offer a different trajectory for Black sociality. While there are any number of examples of narrative fabulation that might serve as a guide, as a theorist of visual culture, I'm particularly inspired by the ways Black artists render Black sociality's improbable capacity to defy the deadly gravitational pull of white supremacy. The practice of fabulation I am describing is rendered not through narrative or narration, but through the Black body itself, and its extraordinary capacity to manifest something I call *Black countergravity*.[3] Black countergravity defies the physics of anti-blackness that has historically exerted a negating force aimed at expunging Black life.

. . .

Complex gradations of gray guide us through a haunting landscape of shadows and open spaces. Solitary walks, absent expressions, and distant looks render a pensive portrait of Black interiority. A clap of thunder and a bolt of lightning jolt us to attention. They signal the coming of bad weather on the horizon. Yet, as the weather shifts and the storm descends, no one seems to flinch or stir. On the contrary, the foreboding clouds and the drama of the weather energize this landscape, infusing anticipation and intensity into the quiet scenes of Black community it depicts.

Kahlil Joseph's 2013 film *Wildcat,* with its evocative score by electronic music producer Flying Lotus, renders a rural Midwestern town as a black-and-white rumination with sumptuous texture. The film captures confident, contemplative blackness set in a landscape that, to some, might signal precisely the opposite. It renders rural spaces that Black folks are schooled to avoid. They are spaces of foreboding that silently telegraph a history of white sheets and knotted rope, flight and frequent recapture. But Joseph's images refuse this narration of their landscape, repainting it instead in a markedly different tonality.

Grayson, Oklahoma

Cowboy hats crown Black and brown heads. They mount and master steers and stallions, and parade linearly or laterally in majestic formations. The rodeo is their ritual celebration. It is a celebration of a community structured by a relationship to land and livestock in a town formed as a means of protection. It is a community created with the intent to transform a landscape of oppression into a domicile of possibility.

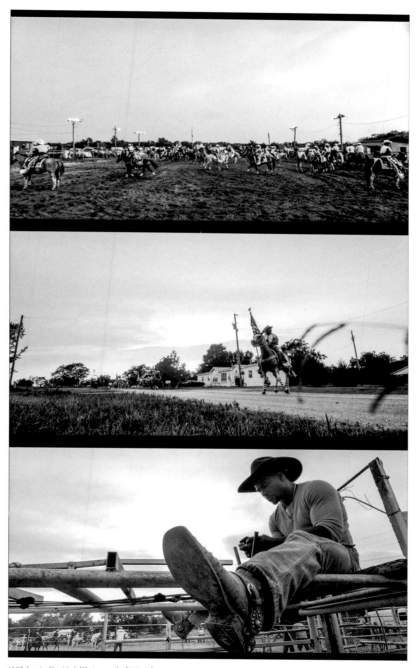

Wildcat, dir. Kahlil Joseph (2013)

Between 1865 and 1915, at least sixty so-called All-Black Towns
were settled in the United States, over twenty of which were
located in Oklahoma. Freedmen from the South initially founded
the All-Black Towns of Oklahoma on land provided by members
of the so-called Five Civilized Tribes, comprising Native American
tribes of Cherokee, Chickasaw, Choctaw, Creek, and Seminole.
At the end of the Civil War, former slaves of the Five Tribes
settled together for mutual protection and economic security.
Grayson, Oklahoma, formerly known as Wildcat, is one of thirteen
such towns that survives to this day. According to the Oklahoma
Historical Society:

> When the United States government forced American Indians to
> accept individual land allotments, most Indian "freedmen" chose
> land next to other African Americans. They created cohesive,
> prosperous farming communities that could support businesses,
> schools, and churches, eventually forming towns.... Many African
> Americans migrated to Oklahoma, considering it a kind of "promise
> [sic] land."
>
> When the Land Run of 1889 opened yet more "free" land to
> non-Indian settlement, African Americans from the Old South
> rushed to newly created Oklahoma....
>
> In those towns African Americans lived free from the prejudices and
> brutality found in other racially mixed communities of the Midwest
> and the South.[4]

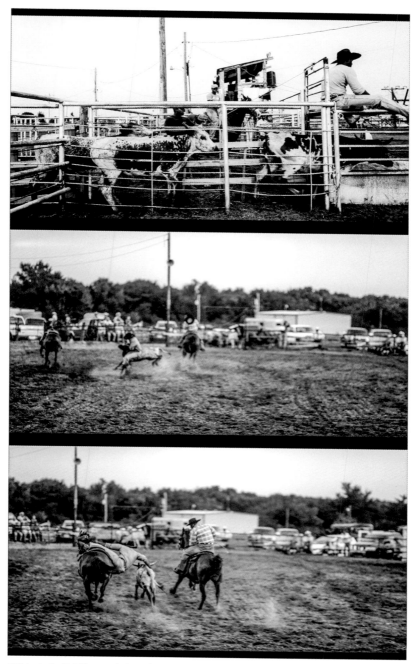

Wildcat, dir. Kahlil Joseph (2013)

Black cowboys shuttle massive beasts through fenced mazes into tight corrals. They mount horses primed to accelerate. They circle and give chase. They ride horizontally and dismount dramatically. They tackle beasts and wrestle them to the ground; grab and tussle with horns and rope. They are pulled and pressed downward, and yet they rise and rise. They bounce improbably upward, dusting themselves off gracefully, to ride and tackle over and again. An accelerating Black cowboy leans into a tight corner turn. But the turn is too tight. Careening downward, the horse buckles and yields to gravity. But gravity does not capture its rider. Falling under the horse's full weight, a Black cowboy never dislodges. Cowboy and horse remount together to full stature, shrugging off the concern of another cowboy, who rushes to extend a hand of compassion and care.

gravity:
the force that attracts a body toward the center of the earth, or toward any other physical body having mass.

a force by which all things with mass or energy (including planets, stars, galaxies, and even light) are brought or "gravitate" toward one another.

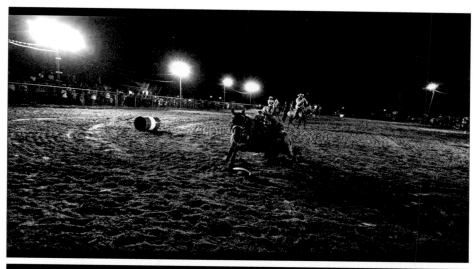

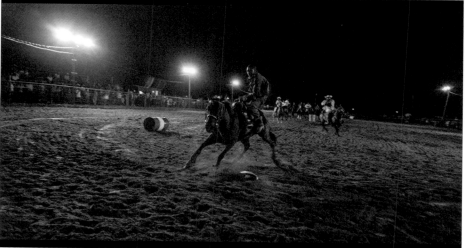

Wildcat, dir. Kahlil Joseph (2013)

Black community, Black celebration. *Wildcat* captures the pleasures
and intimacies of the Black quotidian in a community created as
an antidote to white supremacy. In the late nineteenth and early
twentieth centuries, white Oklahomans sought to block African
Americans from settling in All-Black Towns like Grayson. White
farmers pledged never to rent, lease, or sell land to Black residents,
while others refused to hire Black laborers. Mid-century droughts
and the Great Depression dealt an unrecoverable blow to some All-
Black Towns. Yet, while so many of them failed, Grayson lives on.
Wildcat visualizes an impossible narrative of Black possibility made
real. It is an impossible narrative of Black futurity told through a
Black gaze. It is a future willed into being through the physical and
affective labor of first people, freedmen, and former captives. It is
a labor of love and community, of pleasure and pain, of affirmation
and refusal.

. . .

A brown-skinned boy stands alone surrounded by concrete, a
massive palm tree rising behind his unruly chestnut hair. Dressed
in baggy khakis and a white tee shirt, his arm rises slowly as he
squints, taking aim at a site where his eyes fix in the distance. Hand
extended toward the horizon, his fingers grip an imaginary pistol as
he pulls the trigger to the sound of a shot that ricochets thrice and
boomerangs back onto and into its source. His white tee shirt now
bathes in blood, as its excess flows forth like a tributary seeking an
outlet. The thick crimson stream curves downward like the languid
brushstroke of a master painter, collecting in a puddle just below
his limp body.

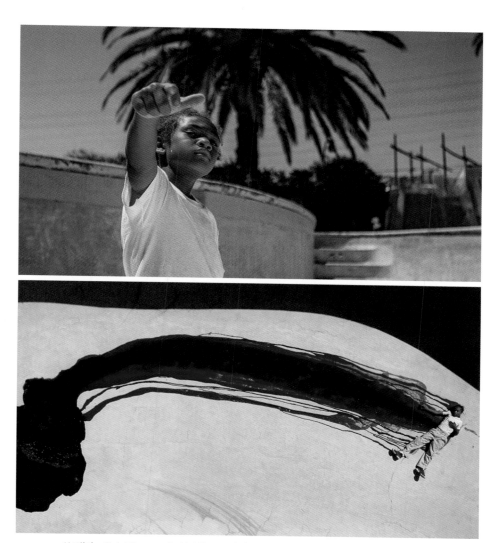

Until the Quiet Comes, dir. Kahlil Joseph (2012)

Nickerson Gardens, Los Angeles

As in the previous film, its location is broadcast as a subtle caption hovering between moving frames. Constructed in 1955, Nickerson Gardens is a 1,066-unit public housing apartment complex in the Watts neighborhood of Los Angeles. Managed by the Housing Authority of the City of Los Angeles, Nickerson Gardens is the largest public housing development west of the Mississippi River. It is the birthplace of the Bounty Hunter Bloods gang, and in 2017 was ranked the seventh "most dangerous" housing project in LA.[5]

When we encounter him in the next scene, his mane is more contained, but his cornrows are far from fresh. He is lively and engaged, mimicking gestures of Black male swagger miniaturized to his tenish-year-old frame. Facing off with his lighter-skinned companion, their cornrows mirror each other as they wrestle on a browned green lawn surrounded by an inner-cityscape of two-story mustard-colored projects. The camera pans toward someone possibly observing the scene, lingering on the furtive looks of a baseball-capped Black man polishing a late-model sedan, gleaming with reflective chrome. It pans again and returns to the boy, this time seated next to and listening attentively to a lanky dark-skinned brother, joined moments later by his round-the-way-girl and a gaggle of three brown boys, who convene convivially on a courtyard bench.

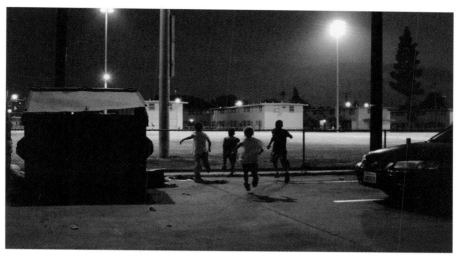

Until the Quiet Comes, dir. Kahlil Joseph (2012)

The boys coalesce as a band of brothers, running, frolicking, and making mischief, eventually returning our multi-shade companions to the browned green field as daylight transitions to a fuchsia-hued dusk. The dreamlike soundscape that guides our tour through Nickerson Gardens slowly fades as we accompany the silhouette of the boy as he glides along the chain-linked fence that surrounds the field. Chin held high, his walk is focused, familiar, and full of purpose.

Our gaze shifts abruptly to a trio of limp Black bodies that echo our opening encounter: a limp body on the ground; a limp body suspended in water; a final limp body on a sidewalk that captures the full attention of our posse of three brown boys, now frozen in stillness. The sound and sight of air bubbling upward through water toward a distant, undefined surface transitions us both sonically and visually back to a Black male body that is, suddenly, limp no more.

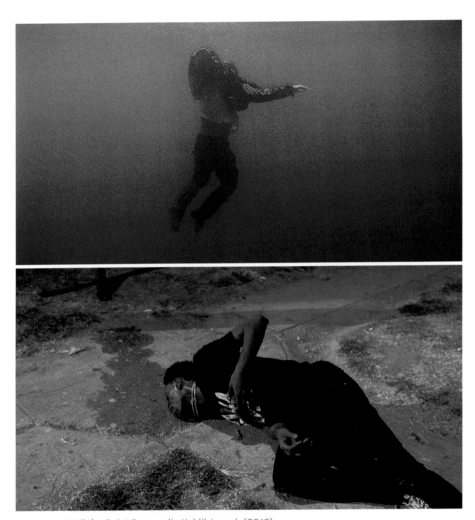

Until the Quiet Comes, dir. Kahlil Joseph (2012)

Hypnotic bells segue to the throb of an electronic drum pumping
a slow deep bass line. Metallic, percussive beats shimmer and
entangle with the throbbing pumps and a haunting tingle of bells.
This sonic entanglement intertwines with the levitation of the
blood-stained, limp-no-more, Black body. His body pulses with the
throb of each beat. It twirls with the metallic percussive shimmer. It
undulates and writhes to the sound of bells and the hiss of cymbals.

He ripples alive and resuscitates himself through an improbable
self-animation that defies gravity. Bouncing from prone to fully
upright, he untangles himself from a blood-soaked tee shirt, to
reveal a magically healed bullet hole in his chest—a mortal wound
amplified by blood that still lingers at the corner of his mouth.
Ambulating with tiny steps on hyperpointed toes, he glides up and
down, backward and forward; he bounces to the ground, rebounds
upward, arches like an angel, then crouches like an angry cat.
He moves neither vertically, nor horizontally; his body bounces
repeatedly, then begins to flow like a fluid material that refuses to
congeal fully into solid or liquid.

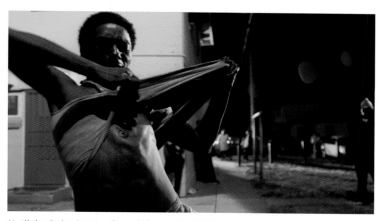

Until the Quiet Comes, dir. Kahlil Joseph (2012)

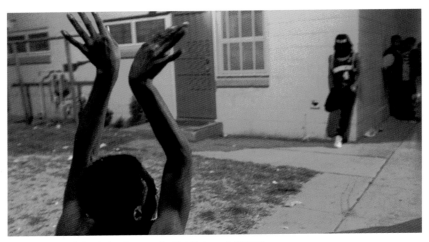

Until the Quiet Comes, dir. Kahlil Joseph (2012)

His flow continues down a path lined with neighbors and
bystanders, possibly family and friends, who, like the three boys
frozen in stillness at the outset of our encounter with the
limp-no-more Black man, also stand motionlessly suspended.
His reanimated corpse flows past their stilled-in-time bodies,
intently making its way toward the promise of a new celestial
plane. As he grazes them closely, he touches some of them tenderly,
and frames others intimately. As he approaches the gleaming
late-model sedan that awaits him on the street, it bounces twice,
seeming to nod in recognition. Its door lowered by the bounce
to just below curb height, he extends a leg at an improbable angle.
Rather than entering, he pours himself into the vehicle, oozing
backward into and through a side window.

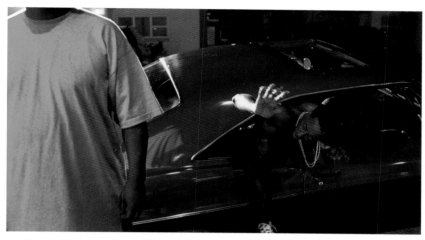

Until the Quiet Comes, dir. Kahlil Joseph (2012)

To state the obvious: both here and above, I am narrating a film. Better put, I am attempting to narrate my encounter with Joseph's stunning four-minute video, *Until the Quiet Comes*—a work awarded the Special Jury Award for Short Film at the 2012 Sundance Film Festival.[6] But I am also fabulating an impossible story of possibility. I am fabulating a tale of Black resurrection and rebirth. It's a familiar story of premature Black death, albeit with a very different ending. It's a story visualized through a Black gaze.

fabulation:

(definition #2)

telling impossible stories to amplify the impossibility of their telling; speculative histories.

trespassing the borders of fact and fiction and recognizing their confluence in the creation of a "documentary" archive of the Black experience/ blackness.

respecting the limits of the archive while remaking it in the process; a creative historiographical praxis of having it all.

—Saidiya Hartman, "Venus in Two Acts," *Wayward Lives, Beautiful Experiments,* and assorted public and private conversations

The impossible story *Until the Quiet Comes* re-visions is the story
of precarious Black bodies figured in an urban setting where
premature death is not the exception but the rule. Joseph
and Flying Lotus's sublimely moving, sonovisual portrait of a
community plagued by unemployment, poverty, and gang
violence seems an impossibly fabulated retelling. But what if we
refuse the inevitable reading of it as a rendering of melancholy,
mourning, and loss in a community riven with violence?
What if their retelling—a dreamlike retelling of resurrection in
the face of violent negation—were in fact the rule rather than
the exception?

Such a refusal would direct our focus toward the improbably stilled
images on the sidelines of Storyboard P's arresting performance
and connect them to the impossible future realized in Grayson,
Oklahoma. It would require us to fabulate from their stilled but
still-moving-images[7] and link their contemporary Black urban
quotidian with that of a Black rural quotidian past and present. It
would require us to see them through a Black gaze that renders
them not passive victims but a community that insists on not just
surviving but actually thriving, against all odds.

Until the Quiet Comes, dir. Kahlil Joseph (2012)

Somber faces lined up on a wall. Girl clutching boy; stoic boy next to equally stoic boy; mother embracing child; girl next to boy next to boy next to girl. Their faces range from mournful to implacable. Detachment or shock; opaque or impermeable; suppressed rage or disbelief—what range of emotions is commensurate to witnessing persistent encounters with premature death? The sepia-washed faces of Nickerson Gardens contrast, yet harmonize with those of their rural siblings depicted in the somber grainy tones of Joseph's black-and-white rendering of Grayson, Oklahoma.

The windswept young couple we watch motoring down an expansive rural roadway are generational inheritors of a town founded to make them free. Their expressions are calm, peaceful, satisfied. What stories might the young residents and heirs to the legacy of this town created as a shelter and a beacon of Black autonomy share with their kindred in Nickerson Gardens, who love so tenaciously and live so precariously in the face of years of Black

and brown gang violence? And what insights might their California cousins share with the youth of Grayson? What impossible stories of possibility might they fabulate together in that conversation?

I believe they would tell adjacent, unfinished stories of Black resurrection and rebirth—stories forged by communities that sustain them in the long history of Black precarity. Yes, they would tell stories of loss, but they would also tell stories of survival against all odds. Those stories would be connected by the common thread of a stubborn insistence on creating, keeping, and holding on to family, friendships, and alternate forms of kinship and affiliation that engender new possibilities for Black futurity.

Perhaps it is my own willful form of fabulation, but to me, Joseph's subtle, evocative visualization of these two very different communities requires us to see Storyboard P's Black flow in tandem with the rebounding flow of the Black cowboys at the Grayson rodeo. Each represents an embodied practice of defying the gravity of violence, social and premature death, structural impoverishment, organized abandonment, and engineered precarity. Each is a demonstration of a Black community's persistent refusal to capitulate to the gravitational forces of the weather, against overwhelming odds. They are visual fabulations of a *Black countergravitational flow* that requires us to do the work of revaluing impossible stories of our struggles with the weather.

Which, believe it or not, returns me to the place where I began this chapter: getting caught up (and caught out) in the weather. It returns me to my soggy trip to LA, and the remarkable installation that lured me onto a six-hour flight to a city that overwhelms me to immerse myself in a third, very special enactment of intergenerational Black countergravity.

. . .

When I arrived at the galleries of the Pacific Design Center two hours after landing in LAX, I was drenched from the pouring rain and completely alone except for a guard who had to wear earplugs to inhabit the space for an extended period of time. It was a sonic environment that made my vocal chords vibrate as if I were uttering tones I was merely absorbing. I was told by the docent at the entrance that some visitors had complained, so the staff felt obliged to prepare people for what to expect before entering. Kind of like a trigger warning, I thought—a trigger warning for an encounter with the visual frequency of Black life.

Mundane scenes of an iconic Black enclave interrupted by somber glimpses of two generationally distinct figures: an older and a younger Black man attired in white shirts, black trousers, vests, and fedoras. They trade places, occupying an expansive loft, a tight hallway, and an equally contained, but paradoxically liberating staircase landing. The older figure sighs with boredom or exhaustion, while occupying a space he refuses to share with his younger twin: a porcelain clawfoot tub. Emerging from a jumble of unidentified voices that comingle with the ambient noise of city life and casual conversation, a voice breaks through to enunciate sentences that echo throughout the film with crystal clarity:

He told me that this city out to be deciphered like a musical score.

One could get lost in the great orchestral masses and the accumulation of details.

Over crowded, megalomaniac, inhuman, he thought he saw more subtle cycles there.

Rhythms, clusters of faces caught sight of him passing.

As different and precise as groups of instruments.

Sometimes the musical passages coincided with plain reality.[8]

Fly Paper, dir. Kahlil Joseph (2017)

House parties and roller rinks, walks in the park or on the avenue, a window overlooking a park, or a cell phone recap recounted while pacing the pavement outside an apartment building. Hailing a cab, riding the subway, waiting for a bus that never arrives on time, snuggling on a couch, or enjoying a conversation at a kitchen table—these scenes of everyday life are "as different and precise" as musical instruments.

Fly Paper, dir. Kahlil Joseph (2017)

Commissioned by The Vinyl Factory in 2017, Kahlil Joseph's sonovisual installation *Fly Paper* premiered in London and was greeted by an acclaim that has only multiplied through subsequent installations in the US at the New Museum in New York City and the Museum of Contemporary Art's Pacific Design Center in Los Angeles—the destination of my weather-plagued, twenty-three-hour West Coast adventure. Inspired by the haunting, sonic photography of Roy DeCarava's soulful portraits of everyday life in Harlem published in the film's 1955 namesake, *Sweet Flypaper of Life*,[9] Joseph's *Fly Paper* plots a parallel journey through contemporary Harlem. Braiding multiple strands of Black family and community together in a complex fabrication of sound and image that pivots between love and loss, *Fly Paper* weaves viewers into simultaneously tender and tenuous relations of intergenerational intimacy.

The piece is a sublime tangle of the sounds and sights of filiation and loss. It gathers footage of everyday Harlem encounters—encounters between the famous and the nameless—overlaid with phrases and quotations spoken not to narrate but to aspirate and inspire contemplation of the beauty of the Black quotidian. It weaves these encounters through complex layering of family and legacy using footage of Joseph's family, including his father, the late Keven Davis, a renowned sports and entertainment attorney. A tireless advocate for Black artists, Davis was a resident of Harlem from late in his life through his death in 2012 of brain cancer. *Fly Paper* merges this paternal presence with footage of Joseph's late brother, artist and activist Noah Davis, founder of the Underground Museum in Los Angeles, who passed away two years after their father. Additional entanglements of filiation emerge through the inclusion of shots of Noah's wife, Karon Davis, daughter of legendary Fosse dancer Ben Vereen, who performs the role of the older Black man featured in the film.

In *Sweet Flypaper of Life*, DeCarava's legendary photographic chiaroscuro harmonizes with Langston Hughes's ventriloquized fabulation of the fictional matriarch Sister Mary Bradley, through whose eyes we view Harlem as an ever-expanding network of family, neighbors, and friends. Their conduit of connection is the streets, busses, and subways that transport them through the city and their neighborhood. Yet Hughes's narrative zooms in to focus our attention on the intimate connections imaged by DeCarava's photographs of the interior spaces Black extended families refashion into spaces of Black joy, intimacy, and care. Framed by the loving gaze of Sister Mary, the kitchen in particular unfolds as a multidimensional space not simply for the domestic labor of preparing family meals. It is a space where friends, neighbors, partners, and kin of all ages cycle into and out of each other's daily lives. It is a space where hair is braided and books are read; a space where drinks are made and music is played. It is the space for Friday night parties filled with slow drags and fast boogies, whoops and howls of laughter, gossip and trash talking and long embraces. It is a space of nurturing and care, a space of joy and affection, a space of rest and respite.

Joseph's *Fly Paper* reanimates the visual frequency of deep blackness that DeCarava captured so poetically in *Sweet Flypaper of Life* by creating a parallel journey of Black transcendence rendered not through sonic photography but through a filmic sound installation that connects the multiple temporalities of Harlem that resonate between these two lush works. In *Fly Paper* we linger on the subway or the playground and meander through parks. We greet and encounter friends and neighbors in hallways, on stairways, or ascending a brownstone stoop. Like the deep black intensities of DeCarava's photographic chiaroscuro, Joseph's camera reproduces deep blackness by filming in graceful shadows. Like DeCarava's close-up black-and-white portraits of laughing, beaming, peaceful,

pensive, reflective, or weary faces, Joseph's camera creates equally compelling portraits of its Harlem residents both as individuals but more significantly as neighbors and friends. Unlike DeCarava's book, *Fly Paper* sets these subjects into motion as moving images with a rumbling intensity that mimics the passing thunder that cuts across the Oklahoma landscape in *Wildcat*.

We follow a Black man in a white hat slowly walking on the block. His halting peregrination is mirrored by that of a similarly clad younger Black man who slows down a moonwalk to hover in place in an empty expansive loft. His slow moonwalk goes nowhere; he restively remains in the same place. Yet, while he lacks physical movement, his stay-in-place locomotion expands and extends time instead. It is a slow walk that connects him to his twin-clad elder in a generational doubling that returns with a vengeance later in the film.

Fly Paper guides us through the urban avenues and green spaces of Harlem by way of a gaze that allows us to encounter its inhabitants at eye level, walking behind and alongside them as neighbors. We see them through a sight line trained on the backs of heads and passing profiles, viewed through eyes of accompaniment as companions and fellow travelers. It is a gaze centered on rituals of movement and assembly that disappear from view in the ordinary routines of daily repetition. Small talk at a house party, watching football with an ailing parent, navigating public transit, quiet play with a child on a lazy afternoon—they are scenes that capture the fabric of Harlem's locally emplaced enactments of Black sociality.

Fly Paper, dir. Kahlil Joseph (2017)

But these are also images that demand heightened levels of sensory attention, for Joseph's masterful sound artistry does not allow us to engage them solely as visual representations. *Fly Paper* is an immersive three-dimensional installation that merges images into a tactile, sonic environment. It creates an image field that registers at decibel levels that rattle the ears and throttle the body. Its enveloping bass line penetrates as it rumbles gallery walls like a clock tower reverberating with the force of bells that toll within it. Its sonic registers transition us through public and private encounters in both open and intimate spaces of Harlem at a frequency we quite literally feel in the throat.

There must certainly be more precise words to describe it, but I can only call it a *boom*—a deep bass that erupts at the climax of the film. It arrives completely unexpected in the midst of our immersion in a soundscape of city noise, snippets of conversation, and brief but mesmerizing musical soliloquys by Lauryn Hill, Thundercat, and

Alice Smith, cloaked in the shadows of a brownstone jam session. And then your heartbeat is momentarily halted by the boom. Watching the installation loop multiple times during my three-hour sojourn in the gallery, I reached a point where my body would anticipate it. I'd close my eyes to let it pass through me, then open them again to observe the scene into which it had transitioned me as if awaking each time anew.

What startled me at first was feeling the sound actually touched me, then finding myself confused trying to figure out where I actually felt it. Sitting on one of the beanbag seats that have become ubiquitous in galleries and museum exhibitions, I felt it pulsate beneath me. Moving to a chair at the back of the gallery, I swore I could feel the sound make contact as a wave of vibrating air. Regardless of where its contact initially landed, its impact was amplified by the remarkable scene that followed and the embodied, generational enactment of Black flow it so powerfully instantiated.

The older Black man makes his way, seemingly disoriented, into a dimly lit hallway. His faltering presence and his stumble in an earlier sequence intensify our sense of his aging frailty. Perhaps it is fatigue from climbing the stairs that slowly become visible at the back of the hallway, which we assume he mounted to access this space. And then comes the boom, and the sound transforms him. It brings him to life as the expressive dancer we recognize him to have been. His improvisations are energizing and enigmatic. He expands and unfolds with outstretched arms and lengthening legs. He seems to grow in height as his spine unfurls to billow like a flag in the wind. Behind him in the background, he is joined by a figure we recognize with whom he shares the space. And in doing so, he transforms it yet again.

Fly Paper, dir. Kahlil Joseph (2017)

Storyboard P enters the frame from the stairway, creeping up slowly and emerging in the older man's shadow. His moves are unmistakable, yet they are different from those we have seen previously. It is a generational duet of an elder body shadowed by its younger incarnation. Rather than the time-altering, liquid flow of *Until the Quiet Comes* or the slow-motion flow of *4:44*, it is a fluctuating staccato flow that connects Storyboard to Vereen's halting corporeal limitations and, at the same time, highlights a striking form of *Black gravity*, embodied most dramatically when Storyboard seems primed to scale the wall of the space vertically, like a spider in pursuit.

Black gravity:

a form of directionality without a destination; the force that propels Black flow.

Joseph's sonically infused visualization of Black gravity in *Fly Paper* illuminates the dynamic relationship between blackness, place, and gravity, and the ways Black communities refuse the existing terms of these relations. Together with *Wildcat* and *Until the Quiet Comes*, *Fly Paper* offers an ensemble of performances that vividly enact the forces that press on, deform, and are resolutely resisted by Black bodies who refuse to capitulate to the weather of anti-blackness, choosing instead to tactically and creatively exploit gravity in their own favor. This sumptuous trio of films provides an inspired depiction of the unorthodox ways Black artists re-vision the precarity of individuals often seen as disposable—in this case, Black urban youth, Black rural youth, and fragile Black elders—through captivating performances of Black (counter)gravity that register both the weight and weightlessness of these groups, as well as their potential for reshaping the future.

Like Joseph's sublime visualizations of Black quotidian life in *Wildcat* and *Until the Quiet Comes*, *Fly Paper* instantiates an equally moving Black gaze. Neither a gaze of identity nor empathy, it is a gaze that focuses on distinctive frequencies of Black filiation. The discomforting labor produced by Joseph's Black gaze in these films resides in their capacity to position white spectators as neither subject nor recipient of their gaze. It is a gaze that centers the Black subject, and whiteness is fully outside of the frame. It thus inverts dominant definitions of the gaze that focus on white male desire as the privileged, if not exclusive, perspective of cinema. Joseph's Black gaze reconfigures this dominant gaze by exploiting white exclusion from and vulnerability to the opacity of blackness. In the process, it demands a very different kind of labor of its viewers.

The Visual Frequency of Black Life

The first time I met Arthur Jafa was one of those rare humidity-free August days in New York City that immediately puts the whole city in a good mood. After a long conversation over a lunch that passed far too rapidly, we made our way south in a cab to visit a gallery downtown. It was during that cab ride that I casually mentioned what had become a kind of mantra I had refined for situations like these. It was a shorthand description (an academic's version of an "elevator pitch") I had developed for explaining my work in a way that didn't bore or annoy people with theoretical jargon or high-falutin' terms and concepts. "I'm trying to write about the frequency of images." Later that day and twice since, AJ recalled his response to my comment: "Did you notice that the whole posture of my body changed when you said that? It was like you flipped a switch and all I could think about was I wanted to hear much more."

I've been obsessed with the frequency of images for a long time. While I introduced this term briefly in the previous verse, Jafa's work offers me the chance to delve into it even more deeply.

frequency:
The rate at which something occurs or is repeated over a particular period of time or in a given sample; the fact of being frequent or happening often.
—*Oxford English Dictionary*

In acoustics, the number of complete vibrations or cycles occurring per unit of time in a vibrating system such as a column of air. Frequency is the primary determinant of the listener's perception of pitch.
—*Harvard Dictionary of Music*

The rate of repetition of a regular event. The number of cycles of a wave, or some other oscillation or vibration, per second is expressed in hertz (cycles per second).
—*Oxford Dictionary of Physics*

"Frequency" is the term I use to account for the impression images leave on us, their impact, and how they move us. As the brilliant musicologist (and former student) Matthew Morrison explained to me, "Frequency is how humans access sound, as sound is a particular physiological manifestation of how we absorb certain frequencies—the vibrations that create a frequency are translated to what we hear physiologically." If we apply the concept to images, frequency is not *what* we see but *how* we see. And as I have written previously, I'm convinced that how we see involves sensory registers beyond visual perception.[1] I'm interested in the frequency of images made by Black communities because I believe that the physical and emotional labor required to see these images gives us profound insights into the everyday experiences of Black folks as racialized subjects.

During that otherwise unremarkable August cab ride downtown,
AJ and I discovered that we share this obsession with the frequency of images—their sometimes stark, though often subtle vibrations, and the often-overlooked sonic dimensions of both still and

moving images. Frequency is at once temporal (a recurrence or
repetition over time in intervals), sonic (it registers as sound and
through pitch), kinetic (it is constituted by movement in the form
of vibrations that occur at a range of velocities and intensities),
haptic (it is a form of contact that registers in embodied forms
through our encounters with objects outside of ourselves), and
visual (a spectrum ranging from the visible to the invisible that
triggers individual responses). And it is these multiple modalities
of frequency that form an integral part of Jafa's cinematic vision.
While many emphasize the sonic frequencies that suffuse his work
through the complex interplay between music and images, I believe
its true power lies in its capacity to register at profoundly moving
visual frequencies in ways that more fully capture the diversity
of the Black experience. Jafa's approach to rendering these visual
frequencies is encapsulated in his most famous catchphrase:

> **"Black cinema with the power, beauty, and alienation of black
> music."**

While this signature motto is regularly cited in articles and reviews
of his work, it remains somewhat of a moving target that many
critics fail to engage directly. "Black cinema with the power, beauty,
and alienation of black music" is an aspiration to deliver the
force of Black music in a visual register. It is an effort to render
its beauty as an aesthetic that exceeds words by augmenting the
visual with the intensity of feeling that defines black music. It is
an understanding of Black alienation not as isolation but as an
exteriority that is both generative and expansive. Jafa's vision of
Black cinema resounds with the frequential depths and spiritual
capacity of Black music. It is a vision achieved through a technique
he calls Black visual intonation:

> Irregular, non-tempered, nonmetronomic camera rates and
> frames... prompt filmic movement to function in a manner
> that approximates Black vocal intonation. Utilizing what I term
> alignment patterns, which are simply a series of fixed frame
> replication patterns... the visual equivalencies of vibrato, rhythmic
> patterns, slurred or bent notes, and other musical effects are
> possible in film.[2]

Black visual intonation mobilizes the instability of Black music,
rather than any form of predictable or reliable structure, to image
frequencies of Black life that consistently "worry" the idea of what
it means to be Black in the twenty-first century. It is a technique
that adapts the edgy, unstable frequencies of Black music to film by
realigning the relationship between film recording and playback. In
doing so, Jafa creates cinema that doesn't just speak to us; his films
sing, moan, and vibrate. His images shutter, slur, and even dance—
all in the tempo and tenor of blackness. Here Jafa poses three
questions that capture the core commitments of his cinematic
philosophy:

> How can we interrogate the medium [film or images] to find a
> way Black movement in itself could carry, for example, the weight
> of sheer tonality in Black song?... How can we make Black music
> or Black images vibrate in accordance with certain frequential
> values that exist in Black music? How can we analyze the tone,
> not the sequence of notes that Coltrane hit, but *the tone itself*, and
> synchronize Black visual movement with that?[3]

In posing these questions, Jafa outlines an approach to Black cinema that incorporates the multiple frequencies I have enumerated above. His idea of Black visual intonation embraces an understanding of frequency (à la James Snead) as an unstable temporality which produces complex forms of repetition that, rather than reproducing or replicating what came before it, creates new beginnings instead. It references a kinetic dimension of frequency that foregrounds Black movement and vibrations, which Jafa incorporates in the structure and form of his films. It is a visualization of frequency that evokes haptic, embodied responses.

Attending to frequency is, at its core, a practice of attunement—an attunement to waves, rhythms, and cycles of return that create new formations and new points of departure. In Jafa's case, it is the choice to attend to something about Black life that traverses the realms of sight, touch, and sound. He invites us to see sound in the movement of images and attend to how music provides an inescapable framework for understanding the capacity of images to both reckon with and represent the full complexity of Black life. Jafa's embrace of the multiple layers of visual frequency signifies an insistence that we attend and attune ourselves to the rhythm of images and their cycles of return. Let us linger and attune ourselves to the visual frequencies of Black life enacted in four of Jafa's short films: *Crystal & Nick Siegfried* (2017), *Sharifa Walks* (2015), *Apex* (2013), and *Love Is the Message, The Message Is Death* (2016).

. . .

Crystal & Nick Siegfried, dir. Arthur Jafa (2017)

A stilled Black face captured in an immobilizing close-up.
Except for the flutter of a lock of hair, it might be mistaken for a
photograph due to its lack of movement. Initially, nothing moves
except the blink of an eye. A hand enters the frame with index
finger extended, appearing almost to poke an immobile visage. It
dwells momentarily on a shoulder, then brushes away a lock of hair
as Frank Ocean croons in the foreground. The camera's gaze dwells
on her endlessly and insistently, baiting our desire to look away and
our failure to muster the courage to do so. She is stunning. Poreless
ebony skin, sculpted shoulders, and a long regal neck exude a
strength that exceeds gender.

Crystal & Nick Siegfried, dir. Arthur Jafa (2017)

Jafa's three-minute video *Crystal & Nick Siegfried* (2017) is an
unflinching, eye-to-eye confrontation with intimacy, vulnerability,
proximity. The hand returns to cradle the shoulder that it recently
left, clutching, massaging, caressing the nape of her beautiful neck.
Ever so slightly but unmistakably, she seems to move away from,
rather than into, this ambivalent "embrace." Does it offer comfort,
affection, apprehension, or intimidation? Somehow, this moment
of contact lacks the reciprocity that would constitute an embrace.
A jarring white-on-black caption—"Boys Don't Cry"—shifts us
abruptly from a shadowy full-face close-up to the profile of a single
eye, to trace the path of a single tear visible only through the track
it leaves on a high dark cheekbone.

Crystal & Nick Siegfried, dir. Arthur Jafa (2017)

What is the relationship between this ambivalent embrace and the
tear that follows it? The caption highlights this dis/connection and
at the same time, queries what assumptions underlie the choice
of the pronoun "she" to represent the individual whose unyielding
gaze has captured our own in this brief but compelling video. It
raises the question of queer desire for an individual whose gender
is potentially undecided, and it registers the affects of the image
by postulating: what solicits a tear, a touch, an uninterrupted gaze?
Bracketed by the disruptive caption and its refusal to grant us the
certainty of assumed gender normativity, what makes us worthy of
access to her intimacy, vulnerability, proximity? We are captured
by an unreturnable gaze that resonates at a visual frequency that
pierces the viewer with quiet intensity.

Sharifa Walks, dir. Arthur Jafa (2015)

A brown-skinned girl strides down a sparsely populated street as a handful of neighbors huddle to watch in the distance. She emerges in all her sepia glory following thirty-one seconds of black screen and the sultry, sexy overture to an Isley Brothers' summer anthem. The warm wash of sun, single-story pastel homes, and occasional chain-linked fences in Jafa's 2015 short film *Sharifa Walks* dupe us into seeing an archetypal LA hood, but Miami's Liberty City is its true location. The girl's chin is high, but her expression hovers between stoic and implacable, asking, perhaps daring, the viewer to probe further. Shifting frames like an eyelid closing and opening again, the camera captures her from multiple angles: side, front, over the shoulder, close-up, full body, at a distance.

Her stride is long, rhythmic, confident. It is a stride mirrored by equally long arms that swing back and forth, punctuating each step. Slowly, painfully slow, the film glides her forward in time, though

only negligibly far in space, as the cuts of the film unmoor her location. A young man completes the frame, joining her in perfect step. Swinging arms and long strides sync; hands clasp and arms arc widely in unison; one becomes two, who become one, only to separate again. Though their eyes never meet and their gazes never connect, they are twinned in forward momentum. Girl alone; girl and boy together; boy ahead, girl behind; girl alone. Slowing yet again, this time to almost stillness; girl and boy reunite—freeze frame, blackout. Purposeful, defiant, intent. As the frame slowly freezes and cuts abruptly to black, have they arrived, do they arrive, at a destination? Do they need one?

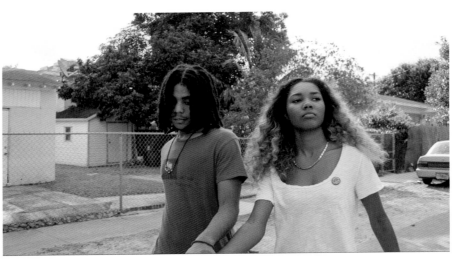

Sharifa Walks, dir. Arthur Jafa (2015)

It is not merely their sublimely slow pace that connects these two films—*Crystal & Nick Siegfried* lacking movement; *Sharifa*, absent motion. They are also linked by their equally sublime speechlessness. Theirs is the frequency not of silence but of *quiet*—a sound unto itself that resonates in the background like the rumble of vibrato. *Siegfried*'s lack of movement vibrates in place at the quiet frequency of a hum, that low-level vibration we feel almost more intensely than we hear it. A single camera shot extends forward in time. Fixed in space, the woman's position never changes, but she is neither static nor still. We are moved by her; touched and affected by her still, yet profoundly moving image.

movement:
change in position of an object in relation to a fixed point in space.

motion:
change of location or position of an object with respect to time.

Like *Siegfried*, *Sharifa*'s motionless walk is a journey rendered in the looping interval of a filmic time that seems to stand still, and in doing so, it challenges the distinction between movement and motion. Walking in this eternal loop, *Sharifa* vibrates at the frequency of Jafa's slurred, bent, or worried note. The couple's suspended, ever-extended walk reverberates in a quotidian tonality. *Siegfried* and *Sharifa* are two rich visualizations of refusal; a refusal to force an image to move, on the one hand, and a refusal to slow an image to complete stillness, on the other. These two distinct but related imaginings of Black intimacy sketch a subtle portrait of a Black quotidian through a gaze that requires us to dwell on quiet, unspectacular moments of intimacy that transcend speech.

Siegfried and *Sharifa* are beautifully executed examples of *still-moving-images*—images that refuse the formal opposition between photography and film. They are images that vibrate in place and in suspended motion both with and without a shift of position in time or space. The subtle motion of near stillness in *Siegfried* forces us to dwell on the beauty of blackness when gender hovers in a parallel state of suspension. In its relentlessly tight, intimate frame, we are forced to embrace its protagonist's opacity and inscrutability.

Both distanced and at the same time vulnerable, the film's intrusively close framing creates an unintended intimacy through our proximity to a tear, skin, pores, breath. We are so close, we can almost touch, if not feel them. But despite the proximity in which the film places us, ours is still the touch of a stranger. It is an excruciating closeness that confronts us with a vulnerability that only deep intimacy can create. *Sharifa*'s slow walk to nowhere, her and her companion's perambulation without a destination or a path, portrays an equally unspectacular scene that reveals both the beauty and the potentiality of a Black quotidian, where the intimacy of tender, everyday encounters creates a path to a different kind of sociality—one where our future is realized not only through tenacious struggle but through the reparative and restorative power of intimacy.

. . .

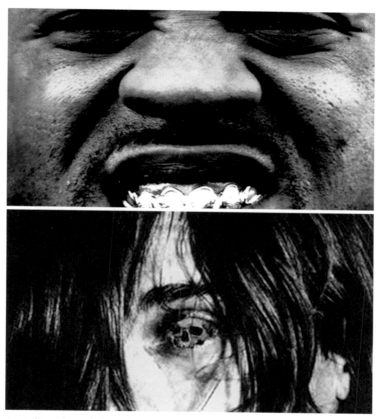

Apex, dir. Arthur Jafa (2013)

Single images of Black and white bodies flash across a screen
for seconds or mere fractions of seconds. White bodies seem
jarringly white: whiter than white; paler than pale; at times almost
translucent. Many are iconic performances of what we might
consider "badass whiteness"—rebellious, provocative, profane.
Musicians, singers, models, and stars merge with black-and-
white cartoons and caricatures, and their equally badass Black

counterparts who punctuate alternating frames with Black bodies in groups, as individuals, and in manifestly disembodied, fleshly pieces. Each frame presents a photograph that appears in a split second only to be replaced by another image at the rate of the blink of an eye. This blistering sequence makes it difficult to dwell on any one of them, as each image momentarily blinds us like the flash of a camera, searing an affective halo onto the cornea of its viewers.

The images register in high contrast, juxtaposing hyperwhiteness against the full spectrum of brown-to-blackness that refracts the distorted hue of white supremacy. Linking the two is the play of painted faces: blackface reappears again and again as the negative mirror of stunning black faces. Black faces grimace defensively in pain, protection, or flexing the prowess of male and female swagger. Black faces contort expressively in the quiet euphoria of reflection or the louder euphoria of excess, exhortation, and exuberance. Extending those faces into full corporeality, Black bodies lie prone and lifeless with flesh riven, exposed, mutilated, or dismembered. Interspersed among them are celestial bodies of suns, moons, and planets, microbial monstrosities, and aquatic curiosities. Threaded from beginning to end, images of Black bodies are disassembled and reassembled as iconic and mundane, fabulous and fierce, defeated and vulnerable, defiant and unfazed. Between and among this shifting palimpsest, a litany of painted faces flashes across the screen: black on white, white on white, white on black. These multiple mutations set in stark relief a familiar figure whose repeated appearance becomes a haunting refrain that merges black and white to mock us with unexpected foreboding: a cartoon of Mickey Mouse that reveals his true lineage and hidden past in blackface minstrelsy.

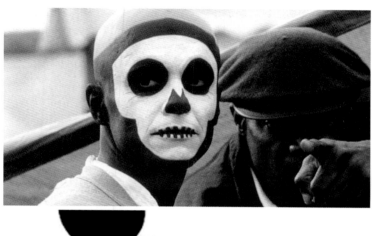

Apex, dir. Arthur Jafa (2013)

Apex (2013) is an energizing and unsettling eight-minute film
that animates a remarkable selection of still photographs curated
to provoke visceral responses. In the midst of this relentless
loop, only two images actually move: the unmistakable rippling
musculature of dancer Storyboard P, and a heavenly line of flight
that tracks the path of an unidentifiable, barely moving aerial
object. *Apex*'s images are gripping, explicit, and at times, graphic:

photographs of the aftermath of lynchings, burnings, torture, and brutal violence intermingle occasionally with entwined bodies, bare breasts or bottoms. Lacking what might be understood as a traditional soundtrack, the film's musical accompaniment is an aggressive techno track created by Detroit DJ Robert Hood. But it is neither what Jafa's images show us nor merely their ability to capture the pained and sublimely beautiful Black bodies that makes them register with such undeniable force.

What makes *Apex*'s images move so vividly and voraciously across the screen to congeal in sonic-visual harmony, only to reemerge and etch a chilling imprint on its viewers? The film begins with a pulse: a rhythmic, piercing sound you feel as much as you hear. Its pitch is unmistakable, yet at first, strangely unidentifiable. It is the pitch of technological precision—of counting and accounting for, of measurement and accumulation. As my student Isaac Jean-François described it: "The sound, which mimics the 'beep' of a checkpoint in a video game or the 'beep' of the checkout conveyor belt at a supermarket, repeats about every second. . . . The beat behind the sequence of images appears to be almost in line with the flash of each image."[4]

The appearance of synchrony (what Isaac calls its "almost" in-line-ness) is the key to this exquisitely moving work. For the pulse of the film is, in fact, *arrhythmic*. It begins in synchrony, then slowly moves not out of time but slightly off-time with the progression of the images, leading viewers to experience an effortful form of arrhythmia themselves. As the pulses slow and fade and resound yet again, as multiple beats overlap and syncopate, then differentiate again into single, serial beats sometimes rising in pitch, sometimes lowering instead, the impact is more embodied than visual.

The pulse registers at a particular frequency—the haptic frequency of a heartbeat—to which viewers instinctively respond in kind by synchronizing their own breath. It is a pulse in the dual sense of the word: a sonic pulsation and the measure of heart/breath that constitutes life itself, the ubiquitous echo of the hospital ward, of bodies wired to a frequency that monitors life. The pulse of life Jafa conjures to animate these still-moving-images tethers Black life to Black death, Black pleasure to Black pain, and Black beauty to its inseparability from the terrible beauty of a Black grotesque.

Apex's irrepressible, irresistible pulse offers a powerful instantiation of Jafa's aspiration both of and to a Black cinema that channels the power of Black music. It is a provocative realization of Black visual intonation where these stunning images literally "vibrate in accordance with certain frequential values that exist in Black music."[5] In doing so, Jafa's radical Black gaze challenges viewers' ability to sit passively in its presence as it compresses over eight hundred individual images into an unsettling eight-minute experience that registers with blistering intensity.

In the formidable filmic trio of *Siegfried*, *Sharifa*, and *Apex*, Jafa's radical Black gaze casts a deeply affecting quality onto scenes of Black life that pivot from mundane to murderous. Positioned askew and alongside their respective musical accompaniments, none of these works includes speech, nor do any of their protagonists utter a single audible syllable.

Yet they are anything but silent. Like Coltrane's mesmerizing compositions and performances, their visual frequency requires us to attend and attune ourselves not so much to the notes (or the sounds, songs, or soundtracks) that comprise them, but to the tonality of our encounter with them.

visual frequency of Black life: irregular rates of vibration that register the differential value of the Black experience.

. . .

Black bodies fall, leap, bounce. Black bodies swoon, fade, wave, fly.
A young boy leaps from stair to step, with flaring shoestrings that
seem to suspend his forward motion. Unlike the preceding trio of
films, in *Love Is the Message, The Message Is Death* (2016), the motion
of Black bodies is inescapable. Like the countergravitational forces
enacted so vividly in Kahlil Joseph's work, the motion of black
bodies in this seven-minute masterwork displays a similar capacity
to defy gravity. Jafa's montage shuttles us through a vertiginous
catalogue of iconic and iconically ordinary faces: Charles Ramsey,
Malcolm X, Angela Davis, Storyboard P, Louis Farrakhan, Coretta
Scott King, Michael Jordan, Michael Jackson, Jimi Hendrix, Scottie
Pippen, Louis Armstrong, Bayard Rustin, Mahalia Jackson, John
Coltrane, Lateria Wooten, Okwui Okpokwasili, Ella Fitzgerald,
Bert Williams, and Chris Brown intersperse and intertwine with
images of Freedom Riders, protesters, strip-club dancers, cowboys,
scholars, feminists, flood survivors, church ladies, mothers, fathers,
brides, and sons; afro-futurist poets, atonal hip hop singers,
resting babies, dancing children. Nina Simone's steely look meets
Aretha Franklin's withering stare and telescopes into Lauryn
Hill's arresting glare in a line of sight that carries forward to meet
the eyes of a brown baby boy, hands up, against a wall, in a gut-
wrenching tutorial from his father on how to survive a police stop
as a Black man in America. His look to the camera seeks approval,
transitions to confusion, and dissolves into tears.

Love Is the Message, The Message Is Death, dir. Arthur Jafa (2016)

Like the powerful montage that unfolds in *Apex*, *Love Is the Message, The Message Is Death* (*LMMD*) delivers an equally arresting assembly of iconic and everyday framings of Black kinship under siege. Yet *LMMD* intensifies the fragmented frame rate of *Apex* by using moving rather than still images. As Huey Copeland explains, "the brevity of the clips mobilized in *LMMD* means that it holds out only

fleeting depictions of individual subjects, as if to hedge against the
visual capture of black folks, while throwing light—and shade—on
viewers' implication in the digital ecologies through which those
images circulate and dis/appear."[6] Throughout the film Jafa braids
tender family videos of his son, his daughter's wedding, friends,
and intimates together with family scenes that display the exact
opposite of tenderness: scenes of a child slapping and screaming at
his mother to "wake up"; dash-camera video of a Black woman and
her six- and eight-year-old children walking backward, hands raised
at the direction of policemen with guns raised against her entreaty
not to traumatize her kids; cell phone video of a young boy of ten
or eleven pleading desperately ("I'm sorry. No! Momma!") as he is
handcuffed by police in their living room.

Love Is the Message, The Message Is Death, dir. Arthur Jafa (2016)

Love Is the Message, The Message Is Death, dir. Arthur Jafa (2016)

This striking montage of disturbing domestic images paints an
unsettling portrait of Black kinship. In between these images,
Jafa incorporates haunting cameos of Black feminist theorists
Hortense Spillers and Saidiya Hartman, creating an insistent
dialogue with their powerful critiques of the afterlife of slavery.
Their inclusion makes it impossible not to feel this film through
their seminal accounts of the destruction and reconfiguration
of Black kinship and domesticity in the transatlantic slave trade.
Proud African men and women, they remind us, were ungendered
and transformed into dehumanized units of cargo. And yet,
throughout their journeys into and beyond captivity, dispossessed
people created alternative forms of kinship—bonds of affiliation
and affection forged not based on blood relations but through
practices of intimacy, solidarity, and exigency that endure in
the present.

The simultaneously troubling and exuberant domestic images assembled in *LMMD* confront us with the terrible beauty of Black life, while challenging us to see domestic images of black communities in the critical frame of what Christina Sharpe calls "the wake."[7] Black domestic images "in the wake"—in the wake of the persistent effects of slavery and dispossession—are far from romantic renderings of family. *LMMD* shows us the bonds of affective kinship created by Black communities through its powerful visual montage of images of Black joy, pain, suffering, and ecstasy.

Love Is the Message, The Message Is Death, dir. Arthur Jafa (2016)

In *LMMD*, Black bodies dance in praise, supplication, desperation, defiance, and jubilation. From a deep bouncing grind to the shudder of a twerk; from the shuffle of Pentecostal possession and release to the choreographed flow of two men's hips shifting side to side, a hand clap and simultaneous folding at the knees only to rebound gracefully to full stature. Jafa's montage syncopates the improbable capacity of Black people to defy the insistent gravity (read: graveyard) of white supremacy.

In his assemblage of lost-and-found footage curated from YouTube videos, newsreels, silent films, family films, music videos, and self-made and archival footage, Black bodies levitate, float, attack. What propels them? Woven throughout are recurring images of the cosmos, with solar flares erupting in vivid tones of red, yellow, and orange, and ferocious alien transports that catalyze the invisible force that seems to animate the film: a seething reservoir of rage. But even as they are assaulted by bullets, buffeted by fire hoses or the body blows of police and bystanders, the flow of Black bodies registers not as an outburst of or capitulation to anger.

But rage is not the frequency of *LMMD*. It is a profoundly caring gaze that guides Jafa's curation of these deeply affecting still-moving-images. It is a gaze that celebrates and embraces the audacity of Black folks to create beauty in the face of centuries of negation. It is a gaze that captures the visual frequency of Black life as *flow*.

flow:
the gradual permanent deformation of a solid under stress, without melting.

Throughout Jafa's oeuvre, Black bodies flow seamlessly across space and time. But it's a flow that requires effort and makes demands. It requires labor, specifically the labor of sustaining a relationship with Black bodies suspended in the simultaneity of joy and trauma. Jafa's capacity to animate Black life through images that recreate the affecting visual frequencies of the Black quotidian—a continuum of terror and joy in blackness—is the

enduring hallmark of his work. In each of these works, Jafa's Black flow evokes feelings of kinship that are differentially accepted or rejected, albeit not as family in any conventional sense. It is a kinship produced when we are confronted with and forced to embrace not only the joy and beauty of blackness, but the suffering and pain that is its dual legacy.

In *Love Is the Message*, we see a gradual, permanent deformation of Black bodies under the stress of racism, racialized violence, and racialized capitalism. But it is deformation as flow: *a deformation without melting, without capitulation*. It is a transformation framed by a gaze that shows us the inseparability of the history of Black suffering from its opposite: Black pleasure. Jafa's joyous Black gaze reveals the link between suffering and virtuosity that is the unstoppable force that propels Black bodies in *Love Is the Message, The Message Is Death*.

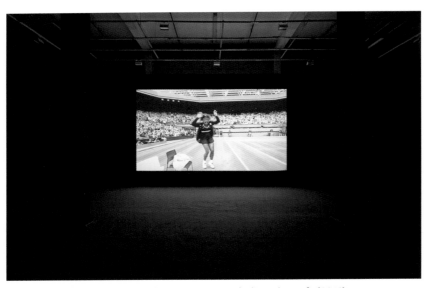

Love Is the Message, The Message Is Death, dir. Arthur Jafa (2016)

Love Is the Message, The Message Is Death, dir. Arthur Jafa (2016)

The bounce of a death-drop rebounding into a ballroom spin, the coordinated hand-slap-jump-back of a circle of little girls, the embrace of Scottie Pippen and Michael Jordan, the hobbled journey of Derek Redmond and his father across an Olympic finish line, the jubilant crip walk of a victorious Serena Williams, the ferocious, clenched-fist stomp and howl of Lateria Wooten belting out a gospel solo, the dismissive rebuke of Minister Farrakhan ("Oh, now, Mr. Wallace . . .") bleeding seamlessly into the vocal rhyme and flow of a young Christopher (Notorious B.I.G.) Wallace—the radical futurity of Black life as flow reaches its apotheosis in *Love Is the Message, The Message Is Death*. It is a futurity that emerges from a Black gaze that refuses to look away, and instead embraces precarity as possibility—the radical possibility of living otherwise.

Thrown to the ground in a bikini by a police officer twice her
age and size, docile she is not. Not only does she rebound in an
attempt to strike her own blow, two other bikini-clad bodies dare
to intercede. Surrounded and outnumbered by twice as many
white police officers, black-and-white news footage amplifies an
indelible temporal continuity with this alarming scene as Black
man in a porkpie hat and skinny trousers kicks and punches while
being assaulted and removed horizontally by a comrade in struggle.
The quiet, yet explosive frequency of Black refusal resonates with
undeniable power in the Black gaze of Jafa's masterwork.

. . .

I've been trying to understand the affects of *Love Is the Message*
since its release in 2016. After seeing it multiple times in multiple
venues, my view shifted from watching the film to watching people
watching it. I watched majority Black audiences and majority
white audiences in the US and in Europe—audiences of artists
and activists, students and strangers, academic colleagues, family
and friends. I saw people breathe in and forget to breathe out. I
watched people smile or wince, chuckle or cover their eyes. I heard
people ask for a break or for time to absorb and digest. I saw people
choke up and cry, or move quietly through its waves of discomfort,
abandon, joy, and rebellion.

What's been most striking throughout is watching *LMMD* push
people to grapple with an intensely visceral and poetic catalogue
of contemporary assaults on blackness. In Jafa's inescapable Black
gaze, the Black body is both subject and subjected, destroyed and
resurgent, abject and resplendent. It is a Black gaze that does not
allow its viewers to be either passive to its labor or impassive to its
affects. It is a gaze that demands the affective labor of *juxtaposition*.

The labor of juxtaposition I am describing is the work required
to see prophetic images of Malcolm and Martin in dialogue with
profane glimpses of strip clubs and drunken house parties. The
work of juxtaposition forces us to see peaceful civil rights marchers
in a continuum with rioting masses burning down cities whose
repressive grip can be suffered no longer. It's a deeply affective
form of labor that allows us to see the link between Black sanctity
and Black sexuality, and to revel in the glorious continuity that
links the solemn propriety of Black church ladies to the awesome
excesses of Black twerkers and grinders. The Black gaze in *LMMD*
makes us work, and the work it requires makes clear that any
oppositional understanding of Black pleasure and Black pain is, at
best, a fiction.

Jafa's careful cinematic and curatorial practices reveal some
of the profound forms of labor a Black gaze both requires and
demands. It is the labor of navigating an emotional response to
what I describe as the *hapticity* of Black life. While some may find
it obscure, "hapticity" is a relatively straightforward term. Deriving
from the root word "haptic" (of or relating to touch), it's a term I
use to describe some of the many forms of contact we experience
as sensate beings in the world.[8] They are forms of contact we are
all too familiar with: physical contact (touching), visual contact
(seeing), psychic contact (feeling), as well as sonic encounters with
different frequencies and vibrations.[9] Jafa's Black gaze adds an
important element to our understanding of hapticity: that it too is
a form of labor.[10] Hapticity is an effortful practice of exertion and
an active form of struggle. It is the struggle to remain in relation to,
contact or connection with another.

Let me be clear: hapticity should not be confused with empathy. It is not putting yourself in the place of another, or feeling you understand or share another person's experiences and emotions.

hapticity:

the labor of feeling across difference and precarity; the work of feeling implicated or affected in ways that create restorative intimacy.

It's not about sharing the pain or suffering of differently racialized subjects. It is recognizing the disparity between your position and theirs, and working to address it. It is the work of feeling done both in spite of and because of these differences, and choosing to feel *across that difference*, rather than feeling *with* or *for* someone living in very different circumstances. It's about recognizing your implication in the circumstances of others and choosing not to be complicit. Far from the satisfaction of feeling identification with someone less fortunate, less secure, or utterly precarious, hapticity is a commitment to feeling the discomfort and the disparities of being better off and doing the work of making them generate a different outcome.

Hapticity is, in this sense, the labor of feeling beyond the security of one's own situation. It involves cultivating an ability to confront the precarity of less valued or actively devalued individuals without guarantees, and working to sustain a relationship to those imperiled and precarious bodies nonetheless. Arthur Jafa's Black gaze shows us Black virtuosity, struggle, and pain, in ways that require the labor of love called hapticity. It is the labor of love required to feel across difference, precarity, implication, and suffering.

As a practice of caring for, looking after, and looking out for others, hapticity is the labor of feeling beyond the forms of alienation produced by a negating gaze of white supremacy, which can only imagine blackness as abjection or supplication. Jafa's Black gaze embraces this negating gaze, turns it inside out, and uses it against itself. In ways that are at times uncomfortable, and even border on unbearable, *Love Is the Message* reclaims a Black visual archive some would see as caricature or evidence of pathology. In doing so, Jafa forces us to commit to the labor of positioning ourselves in relations of proximity, implication, and vulnerability to the full spectrum of Black joy, trauma, and precarity.

. . .

I began this chapter by recounting my entry into an ongoing dialogue on visual frequency with Arthur Jafa and his extraordinary body of work. I must end with a confession about the ways in which the visual frequencies of a Black gaze entangle me as a Black feminist in the complex work of hapticity and discomfort. For hapticity is not just a question of racial sensitivity or sincerity, and not confined to the labors of racial difference. It is the discomfort I too must grapple and reckon with when confronted with the litany of images of precarious Black women and Black femininity that Jafa traces throughout this ensemble of works.

That discomfort begins with *Siegfried*'s powerful stare and *Sharifa*'s aloof carriage. It is magnified by a stream of looks from other women who prod and pummel me in the dialogue between their dueling appearance in still images in *Apex*, and their resuscitation as moving images in *Love Is the Message*. Their doubled appearance links the resolute looks of historical matriarchs past (Harriet, Bessie, Sojourner, and Ella B) to the equally penetrating looks

of their more contemporary sisters in struggle (Nina and Billie, Angela and Mahalia, Beyoncé and Aretha, Ella F and Lauryn). But the hapticity of these images triggers in me the discomfort of knowing that the labors of these women—their brilliant yet frequently overlooked or dismissed intellectual, artistic, political, and cultural work—was never valued equally or fully in their own time, either by their white colleagues or by many of their Black male compatriots.

It is a discomfort amplified by the visual and affective linking of stunning images of Black female artistry, intellect, and sheer fierceness with equally stunning images of Black motherhood under assault. Mothers assaulted or disrespected; mothers watching children ripped from their homes and arrested; mothers pleading with police to recognize the commonsense of treating six- and eight-year-old Black children as just that: children. The juxtaposition of the devalued labor of Black womanhood and Black motherhood with the visualization of its long history under assault provokes a discomfort that compels me to pose a question others before me have asked over and again: is it necessary to witness these difficult scenes yet again?

The concept of hapticity and the idea of a Black gaze require me to answer this question resolutely in the affirmative. For, when I insist upon the labor of others to witness and reckon with Black precarity and our respective proximity to or complicity with it, I must insist that we all embrace the discomfort of a Black gaze that demands we transform this discomfort into something different—something reparative and restorative that values the labor of Black women and Black motherhood in the creation of reparative and regenerative Black futures.

The Slow Lives of Still-Moving-Images

Diminished velocity, duration, delayed development, unachieved potential, reduced exertion—these are some of the many properties associated with the concept of slowness. As someone known for having an excessive travel schedule (or as my father frequently labels me, "an inveterate gallivanter") and as a commuter who shuttles between Brooklyn and Providence to teach, it is no understatement to say that I frequently find myself desperately longing for a much slower pace of life. But I would never have anticipated that I would be forced to slow down, and even stop moving completely, by the total shutdown of the world as we knew it due to the onslaught of a pandemic. In the short space of a few days, I like many others was confronted by what felt like an abrupt descent into what seemed to be an endless loop of Groundhog Days. Marooned in my home, unable to move freely in the world, and hemmed in by my anxiety that the social contact I thrive on puts me and those I love at risk, my world slowed to

slowness:

moving, flowing, or proceeding without speed or at less than usual speed (diminished velocity); requiring a long time, gradual (duration); having qualities that hinder rapid progress or action (delayed development); registering behind or below what is expected (unachieved potential); marked by reduced activity (reduced exertion)

a near standstill. Minutes seemed like hours, while paradoxically, hours seemed to pass like minutes, and days compressed to the point that Monday felt like it was immediately followed by Friday.

The COVID-19 lockdown (or the "Pause" that the governor of New York State spitefully invoked as an escalation of his ongoing feud with the New York City mayor) triggered a profound shift in my relationship to time and movement. Like many residents in the state of New York, one of the early epicenters of the outbreak of the pandemic, I found "pausing" meant moving less and moving much more slowly. But dance and performance studies theorist André Lepecki suggests (citing the work of Jerome Bell) a different understanding of slowness when he writes that slowness is "not only a question of kinetics, but also of intensities, of generating an intensive field of microperceptions."[1] For Lepecki, slowness is more than movement; it is a mode of amplification. It amplifies sensation and attunes us to the intensities of microperception.

Slowness is an opening to linger durationally in the small, in details, in reflection. Rather than delayed or diminished development, it intensifies our perception of any outcome. Rather than reducing exertion, slowness extends and multiplies the energy we must use to engage in a particular activity. Yet Lepecki goes even further when he encourages us to understand slowness as an alternative form of *ethics*. It is an ethics he describes as "a radical mode of composing the infinite velocities and slownesses of being."[2]

Infinite velocities and slownesses of being—Lepecki's imaginative formulation is an invitation to revalue slowness as precisely this, an overlooked velocity of living. It is an ethical practice that requires exertion and develops over time, in and through duration. The intensities of microperception Lepecki describes are the forms of thoughtful focus that slowness requires and demands. Building on these insights, Rachel Anderson-Rabern extends this idea by arguing that slowness constitutes "an ethics of care." It is, in her formulation, an ethics "entrusted to individuals that model their choice to take care, 'so that fewer things will be overlooked.'"[3] And there were indeed were many things we overlooked until the slowness of the pandemic brought them into crystal-clear focus.

We overlooked the fact that while so many were forced to slow down, many were working more than ever, and working harder for insecure jobs and low wages. The pandemic accelerated the lives of those who were, until then, overlooked and taken for granted. Grocery and pharmacy workers, bus and subway drivers, senior caregivers and hospital cleaners, postal workers and delivery people, not to mention parents home-schooling young children and trying to make ends meet while keeping the peace at home—so many of our friends, neighbors, and family were working nonstop and exponentially more than before. Meanwhile, slowness amplified our attention to violence and injustice, and to the fact that it could be tolerated no more. For it was neither an accident nor a coincidence that the massive protests in response to the deaths of George Floyd, Breonna Taylor, and Ahmaud Arbery (and sadly this list will have grown far longer by the time of this book's publication) exploded during a pandemic. The slowness of lockdown amplified these crises, and it amplified the demand to care about Black people and take better care of our communities.

Lepecki's and Anderson-Rabern's words inspired me to consider what a slow ethics of care might look like in the creative practice of Black artists. Their attention to slowness opens up a useful framework for understanding the velocities and intensities of contemporary Black life and, more significantly, the temporality of a Black gaze. For what if we thought of a Black gaze as itself a particularly acute "velocity of living"? What might its temporality be?

This verse gathers some of the conceptual threads introduced in previous verses to dwell more deeply on the temporal dimensions of a Black gaze. While the preceding verses have focused on the kinds of labor a Black gaze demands and the forms of discomfort it evokes, here I want to linger on the fact that a Black gaze requires sustained and durational processes of reflection. The questions I pose above offer a point of entry into considering what slowness reveals about the temporality of a Black gaze in the work of two markedly different artists who are seldom thought of together. As we will see, the dialogue between them is rich and illuminating.

Okwui Okpokwasili and Dawoud Bey are artists who slow down our encounters with blackness. In doing so, they intensify our understanding of the precarity of Black life in ways that solicit our participation in an alternative ethics of care. While their respective enactments of slowness diverge significantly, each uses slowness in ways that require us to take care, to take notice, and to amplify how we care for ourselves and others, and how we care for both the living and the dead.

. . .

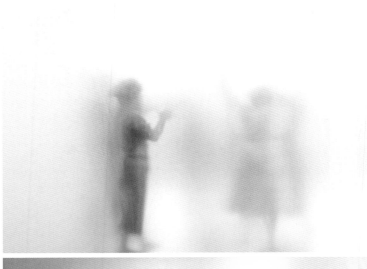

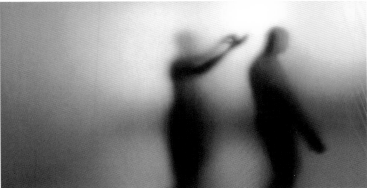

Okwui Okpokwasili, *Sitting on a Man's Head*, dir. Peter Born (2018)

Translucent walls of plastic frame a raised wooden platform. The walls veil a group of ghostlike figures, who on first glimpse, seem almost motionless. Yet what initially appears as stillness is in fact a perplexing form of motion, for the individuals behind these walls are actually walking or, better put, *slow walking*. They are walking so slowly they are suspended in time and hovering in place. Viewing this scene of barely moving shadowy figures from outside the enclosure is a hypnotic experience that hushes conversations among visitors, who watch it utterly transfixed.

Separating viewers from the entrance to the enclosure are a handful of benches arranged in semicircles to create a transitional space: a vestibule where spectators are transformed into active participants. The translucence of the space amplifies this process. Viewers interact at a distance from outside its walls, yet they are participants nonetheless. Those within the space are viewed but not consumed; they are exposed to the gazes of those viewing from outside yet insulated by the filter of its translucence. What unfolds inside is a dynamic enacted by its members' slow, overlapping, intertwining motion.

When I encountered this exquisite practice of slow walking at the 2018 Berlin Biennale for Contemporary Art, I was surprised that several of the figures walking within it were visitors to the installation rather than the purposeful activators I anticipated. While there were dancers and other artists among the activators, their movements were not "choreographed" in a traditional sense. Some gazed downward, others forward. Some seemed hesitant or restless, others more confident and intentional. Their postures, gestures, and subtle movements were accompanied by sounds and melodies that filled the room and drifted out beyond its walls.

Sitting on a Man's Head is the provocative title of this captivating activation. It is a work created by Nigerian-American performer, writer, and movement artist Okwui Okpokwasili together with her partner and director of the piece, Peter Born. In the wall text at the entrance to the activation, they describe the work as "an unfolding score for a collective utterance, the ongoing making of an I, you, we, and us." The work draws inspiration from a ritual practiced by women in eastern Nigeria referred to as "sitting on a man."

"Sitting on a man" is a form of protest used by Igbo women to publicly shame men who have caused offense; it is enacted by gathering at the man's home or workplace (often late at night) to dance and sing scandalous or damaging songs detailing their grievances with his behavior. Women pound on the walls of the home, often remaining all day and into the night, relenting only when the accused man repents and promises change. While clearly an unpleasant and humbling experience, the practice is respected by men in the community, who refuse to intervene or violate the boundaries of the ritual.

Sitting on a Man's Head uses slowness to refashion and redirect this powerful collective strategy for affirming the voices of aggrieved women. While protest, disruption, and redress are its original intent, Okpokwasili reworks the practice as an immersive embodied encounter that initiates a durational, exertive ethics of care. It is a practice that uses ultraslow movement to activate its participants and unwittingly engage them in a process of caring for one another by creating intimate anonymous connections between its participants.

. . .

As I watched the subtle movements transpiring in the space, I became preoccupied by the sounds coming from the enclosure—utterances, tones, and melodies that stubbornly eluded identification. But I was distracted from my search for their source by a figure that lingered at the threshold of the translucent room. He was the first person I had seen leave the enclosure and the first to exit the slow swirl the figures' movements created. I recognized him as Peter Born. As he exited, he walked toward me to initiate a conversation and a new entry into the temporality of slow walking.

When Born invited me into the vestibule to talk, I had no idea what to expect. But as I learned later, this was a practice carried out by each of the artist-activators in the performance. He began by posing a series of unexpected and somewhat overwhelming questions: "What do you think happens after you die?" "What does it feel or look like?" The response he provided was similarly unanticipated: "I imagine it might feel something like the gap you experience when they put you to sleep for a surgery. You count backwards and then you wake up and there's an absent space you can't account for." To which I replied, "So maybe death looks like the absence or a different sense of time?" And then he asked if I was ready to enter the space.

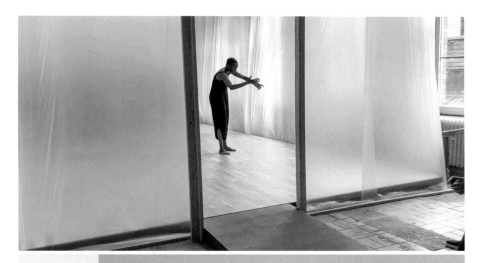

If you come inside "just for a look" you will see the room is "empty".
We ask that you bring something of yourself into the space.

We ask that you bring an action into the space with you:

Move through the space with a slow walk.

Everything starts with breath.
Go to a place in the room.
Find a point of focus across from you. Breathe.
Walk to the other side of the room. Can this last 10 minutes? 15 minutes? More?
Imagine a walk on the moon.
Imagine the Muybridge photo sets: a running horse takes a step over 24 frames.
Slow down every increment of your step.
Stretch the time it takes for your heel to hit the ground,
and then for your toes to follow. A continuous movement.
How many times can you breathe into a single step?
For those not on their feet, the same sense of pace applies: move across the space,
or let your eye wander from corner to corner,
while your head follows, slowly.

Okwui Okpokwasili, *Sitting on a Man's Head*, dir. Peter Born (2018)

His instructions for entering were deceptively simple: take three
long slow breaths and begin to walk slowly inside. Very slowly. It
begins with a shift in weight when you transfer it from your heel to
the outer edge of your arch, through the ball of your foot, and into
your toes. Then you lift it, suspend it in the air for a few moments,
very low, a little higher, higher and higher still. Balance . . .
breathe . . . lower . . . then slowly shift your weight again. It was,
quite frankly, exhausting, exhilarating, and utterly terrifying
all at once. It was physically and emotionally unsettling—an
unanticipated struggle with gravity to remain upright through
subtle weight transitions and ultraslow locomotion. It was
a struggle to remain calm and focused in the face of physical
instability while in intimate proximity with others. Such
intensely focused inward attention creates extreme intimacy and
vulnerability, endless sensation, and heightened awareness. And all
of this together transformed the space and those within it into "an
intensive field of microperceptions."

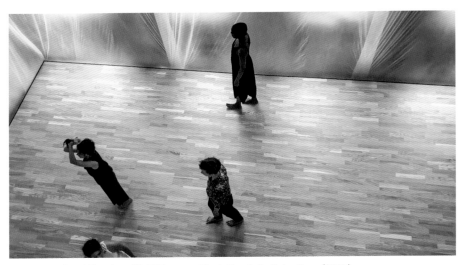

Okwui Okpokwasili, *Sitting on a Man's Head*, dir. Peter Born (2018)

Inside the enclosure, bodies passed one another in the stilled motion of time-lapse photography. The sounds and melodies I initially could not locate were in fact the improvised songs and utterances of the activators inside the room. During my own silent sojourn, they grew louder as a lithe Black male dancer approached me and his particularly moving song drifted toward me. *"I am in me,"* he sang over and again. As he came closer, his mantra shifted: *"I see you," "I am near you,"* and as he passed, it changed to *"I am with you."* His words and song touched me and forged a connection between us. It was an intense and unlikely bond of intimacy created in a space I shared in deep vulnerability with strangers.

The focus required to break bodily movements into increments of centimeters or even millimeters, to sustain those micromovements, remain upright, and not succumb to gravity's insistent downward pull; the focus required to hover in microseconds of nonmovement and antimotion requires an overwhelming confrontation with one's own embodiment. It is a haunting instantiation of the state of being after death that had framed my entry into this unexpectedly precarious space. It is a liminal state that slowly becomes an equalizing practice of stasis—an effortful balancing of forces that suspends the body's relation to space and to time. It returned me to the question that preceded my sojourn within the translucent walls: *what if death was the absence of or a different relationship to time?*

In the space of slow walking created by Okpokwasili, Born, and their collaborators, time was measured not as a relationship to physical space and proximity to others. The passage of time in the space of slow walking was marked instead by how far or how close you were from a point of origin or an unknown point of arrival. Confronting the ostensibly "simple" task of infinitely slow movement initiated a cascade of questions that flooded

my consciousness in the suspended time-space of slow walking:
What is the path you choose to take across the blank space of a
room? What is the distance or proximity between you and the
other bodies inhabiting the space alongside you? Navigating this
cascade of questions while slow walking transformed what began
as an isolated focus on myself, my body, and its locomotion into a
collaboration that raised even more questions: What mediates the
relationship between self and other—when does it merge, intersect,
or diverge? How do you negotiate their nearness or farness? And
how do you "feel" another when no one touches?

Reflecting much later on my experience of slow walking in *Sitting
on a Man's Head*, I could clearly see that this durational engagement
was an embodied experience of many of the elements of a Black
gaze I have sought to describe in these pages. It was the challenge
to remain in balance and to navigate the slow swirl of others
around me without crashing into them. It was the challenge to
equalize one's own precarity and not be pulled off course or into
the orbit of others. Slow walking was an enactment of the ongoing
temporality of Black precarity that forces Black people to strike a
delicate equilibrium between the present, the past, and a future we
are not promised but insist on inhabiting. Slow walking intensified
and distilled what it felt like to physically inhabit an anticipatory
state of Black being where every movement is deliberate and
considered, and any movement could put you off balance and
bring you crashing to the floor. Slowness is indeed a different
relationship to time, but in *Sitting on a Man's Head* it is also a haptic
encounter with the temporality of a Black gaze and what it means
to live blackness in an ongoing state of precarity in which an ethics
of care is an existential means of survival.

I have no idea how long I spent slow walking in Born and Okpokwasili's exquisite enclosure. While there was neither physical contact nor touch, in the shared space of slowness touch and contact are rendered in a different modality: *relation*. Feeling across a shared spatiality requires communication and collaboration and a different relationship to space and time. Bodies must feel each other out; they must feel with, across, and through one another to create a sense of navigation and orientation. Time seemed to stop, and maybe that's what death does actually look and feel like. All I know is that, at some point, I began to hear my own breath. It was not an effect of exertion or exhaustion; I experienced it instead as presence and awareness. I had become part of the space and part of the collective body of artist-activators and strangers who happened to inhabit it with me. I had become part of a chorus.

As I concluded my journey slow walking through *Sitting on a Man's Head*, the body of the lithe Black dancer moved into my peripheral vision. I could no longer see him, but I felt his proximity nonetheless. And in that moment, I could have sworn I saw what looked like the broad wingspan of a heron. Of course, I saw no such thing, but what I felt was real. It was the movement of air; movement animated by his long arms moving slowly and dramatically up and down. As I shared with Okwui later that day, I felt him moving my air. I felt his touch through the movement of the air we shared in the intimate space of slow walking.

. . .

Dawoud Bey, *9.15.63* (2013)

A silver dome, a black dome, a bronze, and a white one line a
nondescript wall where they hover atop black upholstered vinyl
seats. They are seats awaiting clients booked throughout the day. In
these seats, domes will crown heads arrayed with plastic cylinders
taming complex manes; netting or caps will hold hair carefully
pinned into place. Fanned heat will encircle heads for what will feel
like hours. They are seats where women sit for hours, immersed
in magazines and books, and where time feels as if it almost stops
completely.

I'm pretty sure that most Black women (or a huge majority) would
agree with me that a beauty shop is a special form of purgatory. It
is a slow space of endless waiting—waiting to dry, waiting to be
attended to, waiting to finish and be transformed into one's new,
better, or other self. But in our communities, the beauty shop is also
a space of social connection and exchange. In small towns or larger

cities, they are spaces where women converse with neighbors and friends. They are spaces of slow communication, where stories are told at length, in detail, and with relish. Woven into and between washes, cuts, sets, and drys, between relaxers and press-and-curls, between cornrows, braids, and weaves—they are spaces of gossip and inquiry. Viewed through dueling lenses, a camera approaches them achingly slowly, lingering on every detail with a creeping, magnifying zoom, before dissolving slowly into a different scene.

Dawoud Bey, *9.15.63* (2013)

A tall, white rectangular container sits on a counter next to a glass bottle half-full of an amber-orange liquid. One word is visible in the camera's similarly slow creep of magnification: "talc." As it blends into the next scene, we see a longer view of what is presumably the same counter, or one adjacent to or across from it in the same space.

Dawoud Bey, *9.15.63* (2013)

A hairbrush, a comb, long thin scissors, and the distinctive horsehair brushes that distribute the talcum contained in the image align together on a much longer counter. Electric clippers and shavers dangle on hooks at its edge, and at the far end sits an iconic glass cylinder where combs are suspended in the unmistakable royal blue of liquid Barbicide.

Like the beauty shop, the barbershop is also a space of Black communal assembly. Tall tales and bragging rights, sports talk and trash talk—it is a space of male bonding where speed is not the treasured virtue, but lingering most certainly is. In the neighborhood barbershop, time is bent to its limit. Time is exploited and extended to its maximum benefit in a space of intergenerational communion in laughter and one-upmanship that extends the bonds of community. Yet alongside these slow extended shots of empty spaces of Black sociality runs a second, equally slow track that tells a different but connected story when we shift our attention from the left to the right frame.

Our view is directed upward and overhead. We see the sky as
we move slowly forward down a street with dappled sunlight
shimmering through leaves and branches atop tall trees. We see
the peaks of houses and the roofs of buildings made of brick and
clapboard. They are the buildings that might house the spaces we
view from the inside in the left frame. As our journey comes to
an end, our gaze is directed forward rather than skyward, shifting
our view to a sign that slowly comes into view. It is a sign that
locates us in a site that straddles multiple temporalities. It too is
a site of Black communal assembly, but in the pace of our slow
walk, the place where our journey ends is one we must think of
in juxtaposition to the previous spaces, as well as the space that
signifies alongside it in the accompanying frame of children's
drawings hanging on a clothesline in a primary school classroom.
It is a space we see from the outside rather than through its
interior. We view it looking up rather than at eye level from within.
Unlike the others, this space was targeted to deal a mortal blow to
the Black community that assembled in and around it.

Dawoud Bey, *9.15.63* (2013)

Our slow journey follows the path of four little girls in Birmingham, Alabama. It was a path they knew well, as they took it weekly with friends and family each Sunday morning. On this September morning, we don't know how slowly or quickly they traveled, or if they stopped off or lingered along the way. All we know is that this journey was the last for fourteen-year-olds Addie Mae Collins, Cynthia Wesley, Carole Robertson, and eleven-year-old Denise McNair. It ended on the morning of September 15, 1963, when these four girls lost their lives in the bombing of the Sixteenth Street Baptist Church in Birmingham.

Dawoud Bey's eleven-minute, single-channel video, *9.15.63* (part of his larger acclaimed work, *The Birmingham Project*), traces the path these four girls took to their untimely death in 1963. Through Bey's camera, we view scenes they might have seen along the way, observing the foliage, the built environment, and the social spaces they might have passed en route. The diptych juxtaposes slowly filmed moving images on the right with images on the left of empty spaces of Black life filmed so slowly they appear as still-life photographs. Together they create a lush, quiet array of still-moving-mages that ruminate not so much on the tragedy of loss and death as on our contemporary relationship to this not so distant past and its continued resonance in the present.

Dawoud Bey, *The Birmingham Project* (2012)

Dawoud Bey, *The Birmingham Project* (2012)

Seated in chairs or in pews, arms folded or resting on an elbow. Head propped up or cradled by a hand; hands clasping an elbow, laid one over another, or draped on a lap. This set of photographic diptychs form the core of *The Birmingham Project*—still images that echo the still-moving-images we have just viewed. The gaze of each duo is fixed firmly on the camera. It is a gaze that confronts viewers from the perspective of a tripled temporality. It is a temporality that begins with a shared place of residence that positions each sitter in intimate proximity to September 15, 1963, for the younger person in each duo is the age of one of the murdered girls; the elder is the age she would have been today. Together, they straddle multiple temporalities we must conjugate in a subjunctive grammar, where the query, *What if it had been me?* is mirrored by its twin: *It could have been me.* Yet, while they live in the shadow of this heinous crime, they also live in the subjunctive grammar of "as if." Live your life *as if* this day were your last. Live *as if* it could have been you, but wasn't. Live *as if* it could still happen, because it still can . . .

The Birmingham Project slows down our gaze and forces us to listen to the echoes we hear between overlapping temporalities of white supremacy. They are the echoes that ricochet between the bombing of the Sixteenth Street Baptist Church in Birmingham in 1963 and the massacre in Emanuel African Methodist Episcopal Church in Charleston, South Carolina, in 2015. They are echoes between Bull Connor's invocation of vicious dogs in Birmingham in 1963 and a racist president's calls to set similarly vicious dogs on peaceful protesters in Washington, DC, in 2020. These images force us to slow down and linger in the chilling resonances of long lines of mourners paying their respects to the open casket of Emmett Till in 1955 and equally long lines of those paying similar respects to the open casket of George Floyd in 2020.

Yet slowing down our gaze to dwell in the spaces of Black
sociality surrounding the Sixteenth Street Baptist Church or in
the triangulated temporalities of four murdered girls and their
generational age equivalents in the present also focuses our
attention on the informal networks of community that have
sustained Black families through their losses, and galvanized them
in the fight against the forces that seek to rob them of friends and
kinfolk and the futures they want to live. Slowness makes us attend
to the function these spaces serve not only as generative of Black
social life but as nascent sites of rebellion. For Black barber shops
and Black beauty salons are also spaces of activism and education:
they are spaces where marches were advertised, where protest
literature was distributed, and where activists were recruited.
They are places where meetings were held, plans were hatched,
and news was shared and disseminated. They were conduits of
communication for the work of getting free.

9.15.63 requires us to linger in the durational, overlapping
temporalities of Black precarity. We walk in the steps of these four
little girls in the knowledge that this path led to their demise. We
view it through their eyes and from the fabulated perspective Bey
so beautifully conjures. In doing so, we are forced to inhabit both
the knowledge of their impending murder and the innocence that
denied them any inkling of the vicious acts that would rob them of
their future. It is the innocence that allows a child to gaze upward
and lose herself in daydreams of clouds and treetops. It is the
innocence of having your whole life ahead of you and believing
anything is possible. It is the innocence of going for a run in your
own neighborhood or bird-watching in the park, believing you pose
no harm to anyone. It is the innocence Black girls and boys and
Black women and men are entitled to, but so often denied. *9.15.63*
forces us to adopt the gaze of Black innocence and Black innocence
lost—and to dwell in its slowness.

Slow dwelling in lost innocence challenges us to withstand the intensities and infinite velocities of Black being that require us to bear the weight of loss and sustain the link between the living and the dead. It is the slow labor of lingering on details we take for granted in the everyday spaces of our communities, seeing through the eyes of the departed, and retracing the final path taken by four Black girls whose loss galvanized a movement. We are confronting this moment yet again, and yet again we refuse to capitulate, even in the face of a pandemic. The pandemic has indeed forced us to slow down, but in slowing down, it has intensified the struggle. It has amplified a slow practice of witnessing and an intimate practice of care—caring enough to listen to those we have lost, and insisting that they are avenged in the present and will never be forgotten or forsaken to the past. It is a slow practice of care "entrusted to individuals that model their choice to take care, 'so that fewer things will be overlooked.'"

. . .

Dawoud Bey, *Night Coming Tenderly, Black* (2017)

A *tangle of vines* *on a path strewn with leaves.*

Dawoud Bey, *Night Coming Tenderly, Black* (2017)

The tops of trees reflected in a marshland pond.

Dawoud Bey, *Night Coming Tenderly, Black* (2017)

A creek that runs through the woods behind the farmhouse

These are a very different set of images conjured by Dawoud Bey's sumptuous camera. They are photos from his 2017 series *Night Coming Tenderly, Black*. They are images with a very different tenor and a very different tone from those of the *Birmingham Project*. These images require us not only to look, but to listen as well. Extending the slow, durational engagement inspired by Lepecki and Anderson-Rabern, and enacted by Born and Okpokwasili, as

well as by Bey in *9.15.63*, and weaving these together with the visual frequencies of the Black gaze explored in the preceding verses: rather than simply viewing these images, what if we listen to them as well? What do we hear, and what do we encounter in the process?

Listening to these somber images, what we hear in them is not silence, it is the sound of quiet. It is an unmistakable sound that enfolds us in the hazy hum of nightfall, which we hear as much as we see it. It's a quiet hum of crickets and cicadas, tree frogs and evening breezes. We can't simply look at these images; we must enter them instead. In doing so, we witness these scenes through a distorted halo of moonlight as our eyes adjust to the shadows of dissipating light. We take them in against a quiet backdrop of rustling leaves and tiny twigs crackling underfoot.

As I have written elsewhere (and will fervently assert any chance I get), quiet is not the same as silence. It is not an absence of sound; it is precisely the opposite. Quiet is a profoundly expressive sonic environment. It is densely packed with sounds we often overlook—background murmurs; ambient buzzes of people, cities, and nature; or the whirring of industry or technology.

quiet:
a sonic modality that infuses sound with impact and affect; a sonic frequency of contact and touch; a frequency perceptible through vibration rather than pitch.

Quiet is a complex sonic field that I find useful to think of as analogous to the intensity of blackness in the visual field we know as color. Unlike the "color" white, which isn't actually a color and only reflects the colors around or proximate to it, the color black consists of all colors at once, merged into something that may appear to be a void, yet which is, once again, anything but. When we linger on blackness and attend to it closely, we see the full spectrum of color, from beautiful hues of blue and green to vibrant shades of violet and red. Like blackness, quiet deserves careful attention.

Quiet is a fulsome sonic environment. It is infused with a
multitude of sounds that register at low frequencies. Quiet is the
sonic background to and (infra)structure of listening that makes
other sounds register as loud or soft. Indeed, I would argue that
sound only registers as audible *in relation to quiet*, because the total
absence of sound that we call "silence" rarely, if ever, exists. For
this reason, we must attend to quiet with care and intention, as it
holds within it whole worlds of expression.

My preoccupation (some might say, fixation) with the sound of
quiet compels me to listen to images; it compels me to listen to
how images register and affect us beyond what we see. Which
brings me to a question that is posed to me again and again: how
exactly do we listen to images? We listen by feeling. We listen by
attending to what I call "felt sound"—sound that resonates in
and as vibration. We listen by feeling the vibrations
that emanate from images we think are silent,

hum:
a sound made by producing
a wordless tone with the
mouth opened or closed,
forcing the sound to emerge
from the nose. To hum is to
produce such a sound, often
without a melody. It is also
associated with thoughtful
absorption, "hmm."
—Wikipedia

but which I would argue are anything but. It is
a listening that attends to how these vibrations
solicit both subtle and powerful responses in and
from us. I listen both intentionally and specifically
to their lower frequencies. Put another way,
I listen to their quiet. It is a quiet that, to me,
registers at the insistent frequency of a *hum*.

I know a lot about humming. I know a lot about humming because my dad is a champion hummer. I adore my dad's hum. His hum has been a kind of sonic lifeline that's carried me through some of the most difficult and momentous events of my life. My dad hums with vigor and virtuosity. He hums joyfully and contentedly. And while he maintains that, as a passionate tenor, he hums as practice for his choral performances, I am quite convinced that more often than not, he hums completely unaware of himself. In fact, you used to be able to hear his hum on his voicemail message (sadly, when I mentioned this, he rerecorded it!). And I continue to delight in the fact that my dad often hums unknowingly when he leaves messages on my voicemail just after he finishes his message, right before he hangs up the phone.

A hum can be mournful and can feel like a gnawing gritty scratch. It can also placate, caress, and hold. It can rock you like a baby, or soothe you like a reassuring massage. It can irritate or haunt, grate or distract. But it can also be joyful and mischievous. Or it can just keep you company whether you are alone or in the midst of a crowd of people. My dad's hum is not the melodious kind one might initially associate with the idea of humming. His hum is rhythmic and vibrational. It's persistent and durational. His hum locates him in the house and tells me when he's coming into or leaving a room. And I am convinced that his hum leads him from task to task and from thought to thought throughout the day. Perhaps most importantly, my dad rarely hums an actual song. It doesn't have verses or choruses; it doesn't have a beginning or a middle or an end. It's a loop that repeats and repeats. It's meaningful not for what it says, but for the focus it provides, and the attention it accumulates. Having inserted the sound of my father's hum in your ears, I invite you to listen to the complex quiet of Dawoud Bey's *Night Coming Tenderly, Black.*

Dawoud Bey, *Night Coming Tenderly, Black* (2017)

A white picket fence in front of a clapboard home.

Dawoud Bey, *Night Coming Tenderly, Black* (2017)

A farmhouse viewed through a clearing of trees.

Dawoud Bey, *Night Coming Tenderly, Black* (2017)

A closer view of the porch landing through the foliage of shrubs.

The hum I listen to in these haunting images is a foreboding hum that makes you prick up your ears. For sometimes that crackle is not coming from you; it's coming from somewhere or someone else instead. And then the hum becomes a buzz of preparation when you sense you're not alone, regardless of what you may or may not see. Nearby or farther away, it transforms into a hum of alertness to your surroundings, whether you share them with another, and whether that other is friend or foe.

I enjoy listening to these images because I love listening to their complicated layers of quiet. *Night Coming Tenderly, Black* is a collection of photographs taken in and around Cleveland, Ohio, that give this lakeside city a very different soundscape. It is not the sound we associate with its current urban incarnation. Bey's portraits are meant to return us to a quiet place where the present meets past histories lived in this city when it was a gateway between bondage and freedom. He describes them as images intended "to evoke the sensory and spatial experience of fugitive slaves moving through the darkness of a pre-Civil War Ohio landscape—an enveloping darkness that was a passage to liberation."[4]

Known by its codename "Station Hope," Cleveland was an important destination for fugitives traveling through a network of safe houses with the help of the dedicated abolitionists who served as "conductors" on the Underground Railroad. As a state that shared its southern border with two slaveholding neighbors, Ohio played a critical role as a pathway to freedom for the enslaved. When they reached Cleveland, fugitives were led eastward to Buffalo or westward to Sandusky and from there, on to Canada. But the city's harbor was also a crucial pathway to freedom, as steamers docking in Cleveland ferried numerous fugitives across Lake Erie to a new life beyond bondage.

Dawoud Bey, *Night Coming Tenderly, Black* (2017)

Storm clouds hover low over the rough waters of a great lake.

When we listen to Dawoud Bey's still-moving-images, we hear anything but silence. We hear instead a quiet, insistent hum. It is the hum of our present facing off with our past. It is the bold but apprehensive hum of fugitives moving under the cover of darkness, listening intently to the fulsome quiet of nightfall and its multilayered soundings. It is an anxious hum of being so close to liberation you can see and almost taste it.

But perhaps they were also humming—softly, almost imperceptibly—to themselves and each other along their journey. Humming no particular tune, without a verse or chorus or refrain. Perhaps they were humming in a repeating loop like my dad, humming to calm and to soothe and to make their way through to the other side. Perhaps they were humming that nervous, expectant hum that's more of a vibrato in your throat than an actual melody. Perhaps they were humming the quiet soulful refrain of freedom.

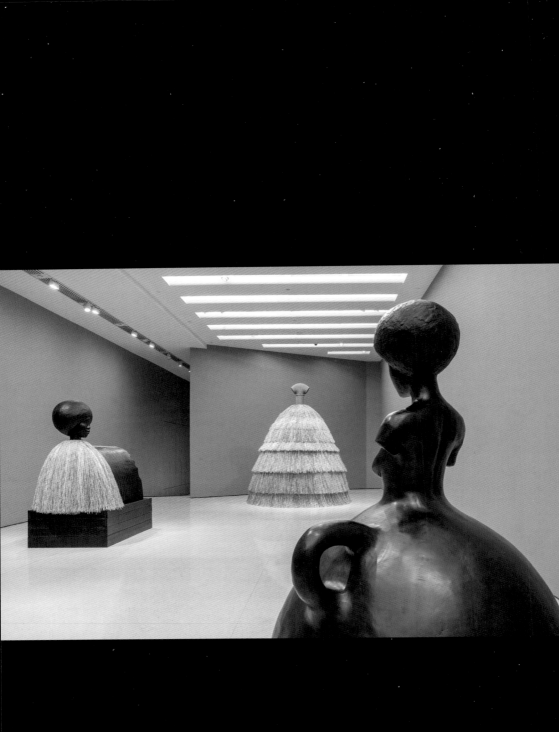

Sounding a Black Feminist Chorus

It is perhaps her signature statement, and one I truly wish I'd had the pleasure of personally hearing pass her lips: "My primary audience is Black women."[1] Simple, direct, defiant. But I'd neither heard nor read it the first time we met. She was one of a group of Black women I immediately bonded with in the sweltering courtyard of the Kunst-Werke Institute for Contemporary Art (affectionately known as the KW) during the 2018 Berlin Biennale. It was my first encounter with the extraordinary body of work that comprises the multimedia practice of Simone Leigh.

I was too shy to reach out to her later and ask to see the film again privately. But fate and the art world had other plans. Following a triumphant solo show at Luhring Augustine Gallery in 2017 and coinciding with the installation on the New York City High Line of her majestic sculpture *Brick House*, Leigh was awarded the 2018 Hugo Boss Award for Lifetime Achievement in Art. It was her subsequent solo show hosted by the Guggenheim Museum in honor of this achievement, "Loophole of Retreat" (2019), that led our paths to converge once again.

loophole of retreat:

the dark enclosure of an attic space where she plots and plans

she dreams of possibility from within impossible strictures
of confinement

her escape is immanent, as her imagination is boundless

her enclosure is an incubator for a practice of refusal and a
roadmap to freedom

These words describe the plight of an enslaved girl who dreamed
into life practices of self-care and intellectual fortitude, executed
cunning acts of subversion, and exercised fugitive forms of love
and connection. They are a sampling of the multiple registers
of the loophole of retreat Harriet Jacobs chronicled in her 1861
account, *Incidents in the Life of a Slave Girl*,[2] where she described her
struggle to escape captivity and the seven years she spent hiding
in the attic crawl space of her grandmother's home. A loophole is
a way out, an escape route or a means of extricating oneself from
a seemingly impossible situation. A retreat is a place of sanctuary,
seclusion, and refuge—or a pathway to elude or escape from an
enemy. Harriet Jacobs's loophole of retreat was all of these at
once: both a safe harbor and an escape route from a seemingly
unwinnable struggle.

These registers of fugitive creativity and possibility are referenced by
Simone Leigh in the title of her 2019 show—an exhibition described
by its curators as an expression of the artist's enduring commitment
to visualizing Black women's intellectual and creative labor. The
loophole of retreat is a place Jacobs claimed as simultaneously an
enclosure and a space for enacting practices of freedom—practices
of thinking, plotting, envisioning, and realizing alternative forms of
possibility. Continuing Jacobs's legacy of enacting furtive forms of
freedom from within the confines of enclosure, Leigh revalues forms
of Black women's labor too often rendered invisible.

· · ·

What caught my attention as soon as I entered the space was the familiar sound of the clap-slap-song-play of a Black girl assembly that could erupt anywhere they are allowed to occupy a space on their own terms. My ears fastened tenaciously on this unmistakable chorus in the larger soundscape suffusing the small space. A playground, a city stoop, a suburban backyard, a country porch— the coordinated synchrony of hands, voices, and shared gazes is a signal that you are entering a space where Black girls rule. An assembly as small as two or expanded into multiple synchronized dyads—if you know the rhythm, the rhyme, the pattern, or the tune, you are welcome to join. Black girl time, Black girl rules.

chorus:

an organized group of singers or an assemblage of independent but coordinated voices brought together to create a simultaneous utterance.

(in Greek tragedy) a group of performers who comment critically on the main action of a play.

The sound, sights, and touch of my childhood distracted and inundated me as I listened in the corner of a chamber constructed of latticed concrete blocks—a sound installation Leigh dubbed *Loophole of Retreat I.* I responded to the need to dwell in the space by sliding down a wall and taking up my habitual posture of sitting cross-legged on the floor. This time my seat was on a concrete floor at the base of a wide bronze cylinder elevating a crown of twisted cornrows atop a conical, chestnut-glazed ceramic form. My vantage point in the enclosure placed me at the feet of a steady stream of visitors that I watched mill in and out in silent consternation, seemingly perplexed by the meaning of what they found within its four walls. Yet they quickly disappeared from my view as I found myself swept up in the sounds that suffused the space.

Barely decipherable voices mingled with ambient refrains and samples of horn riffs, drums, hums, and freestyled solos. A percussive rattle jostled with an improvised melody, ending with

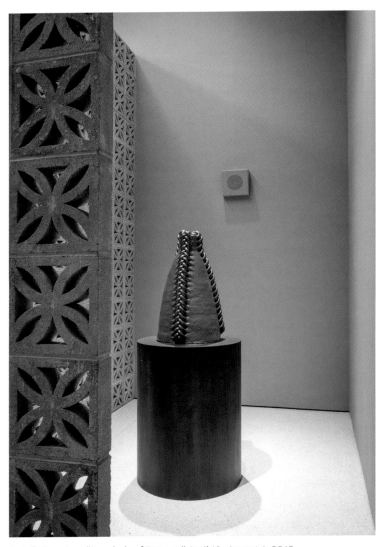

Installation view: "Loophole of Retreat," April 19–August 4, 2019,
Solomon R. Guggenheim Museum, New York. Photo by David Heald.

a chuckle and a giggle. It blended seamlessly into the muffled cry of a baby and a repeated refrain—"*I love you*"—that looped equally seamlessly into a reprise of the clap-slap-song-play of the Black girl assembly transposed against a background of a late-seventies urban beat. Sharing the name of the exhibition's title, the installation is a sonic instantiation of a loophole of retreat.

The soundscape created for the installation by Leigh in collaboration with musician and poet Moor Mother layers these quotidian sounds over older musical samples and more recent audio from contemporary prison protests. Heard within the latticed concrete walls, this eerie soundscape reverberates in conversation with the ceramic head of coiled tendrils to create a zone of what Leigh calls "sonic protection."[3] It is an installation designed to render what Black women's labor of protection might have sounded like in one particular year: 1978.

An unremarkable year for some, 1978 was the year Debbie Sims Africa gave birth to her second child at twenty-two years of age while incarcerated at the Cambridge Springs women's prison in Erie, Pennsylvania. She was charged and later convicted along with eight other members of the Black liberation group MOVE in the aftermath of a police siege of their headquarters and communal residence in Philadelphia for the death of an officer during their military-style incursion. Although the officer was killed by a single bullet, all nine were convicted of "collective responsibility" for his death.[4] Debbie Africa was eight months pregnant when she was arrested, and eventually served forty years in prison before being granted parole in 2018. Five weeks after her arrest, she secretly gave birth to her son David in her cell.[5]

Loophole of Retreat I pays tribute to the labor of one woman's extraordinary effort to spend three uninterrupted days bonding with her son before being separated from him by prison authorities.

It pays tribute as well to the efforts of her incarcerated sisters, who worked to conceal his birth and create a protective space of refuge and sanctuary for mother and child. It honors their collective labor by recreating a space of sonic protection akin to that which these women created for Debbie and her son, when they alternately stood vigil outside her cell and sang, coughed, or created other forms of sonic interference to shield her child from detection. It was through sound that they constructed a collective wall of protection and a three-day loophole of retreat for mother and child. It was their chorus of Black women's insurgency that sounds with haunting urgency within the perforated enclosure of *Loophole of Retreat I*.

. . .

It was over an hour before I managed to disentangle myself from the soundscape of the installation and return to the surrounding gallery, where three towering figures stood proudly in a commanding triangle. One faces the figure opposite, seemingly transfixed by her presence. She does not return the gaze, but does not look away. Smooth black surfaces stand in for what should be the figures' eyes, but it is an absence that in no way signals a lack of sight. They hold each other's gazes; they hold each other's presence. They rest and hold each other in what becomes an almost sacred space of quiet intensity.

A flawlessly formed, afro-adorned head rests on a beautiful, bare torso. It sits atop wide ebony hips that extend into the handle of a vessel. Another equally flawless afro-adorned head rests not

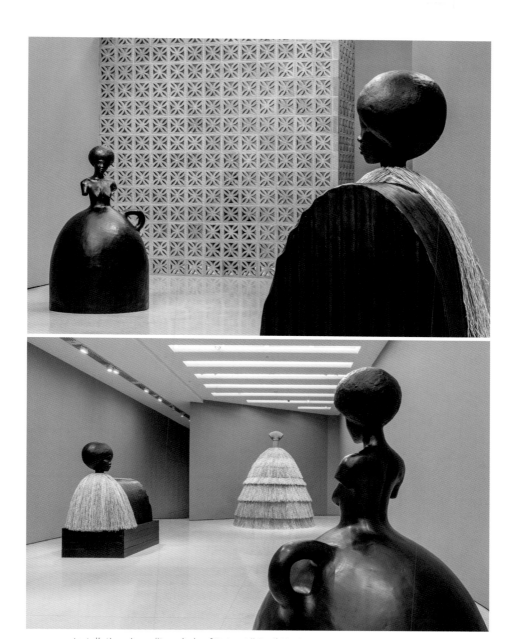

Installation views: "Loophole of Retreat," April 19–August 4, 2019,
Solomon R. Guggenheim Museum, New York. Photo by David Heald.

on a torso but finds its anchor instead on the fullness of a grass skirt. But it is a skirt that sheathes her only partially. What is left uncovered is a structure that expands beneath her. Resting alongside her and rendering her in a sphinxlike repose, it is not a body that radiates outward from her billowing raffia skirt; rather, it is a corrugated, accordion-like structure resembling a silo. Like a silo, she is both a repository and a vessel. She is a shelter.

vessel:
a container for holding something; a person into whom some quality (such as grace) is infused.

The third figure sharing the space is an equally commanding presence whose multitiered straw skirt supports a stovepipe at its apex that mimics a torso. Similar to her sphinxlike sister, her figure is both a persona and a domicile. While the gazes of Leigh's monumental black figures are obscured, they penetrate and pervade nonetheless. The absence of eyes that should serve as the sources, origins, or conduits of these looks intensifies our search for contact and connection. Their absence amplifies a look that is there but not there. It is a look that seeks us out even in its erasure. United kindred in the gallery, the three figures create a sheltering space of care, providing refuge as a group that watches out and watches over. They are a trio who embrace without touching, speak without words or sound, and gaze without eyes with power and grace at one another and at us. Like their sibling sound installation, *Panoptica, Jug,* and *Sentinel* cohere as a chorus.

In his review of the exhibition, Seph Rodney begins with a confession: "I wouldn't normally expect an object that's meant to defy the inquisitive gaze to be as large as this."[6] He is correct; they

are monumental figures, ranging between eight and ten feet high. But why not expect their monumental stature? Isn't their scale part and parcel of their defiance as an overt response that rises to the challenge of a gaze that routinely seeks to probe, diminish, and overwhelm Black women? While I agree with Rodney that these works do indeed "defy the inquisitive gaze,"[7] and that the absence of eyes in these and multiple other sculptures in Leigh's broader oeuvre is significant, let's just say I think it's a bit more complicated.

Yes, Leigh's work denies a "white and dominant" gaze, but I believe we underestimate its power when we understand its impact as achieved either reactively or at the level of negation or reserve. Its purchase resides instead in the power of opacity, which produces its own form of scrutiny and, in turn, its own distinctive gaze. As Rodney rightly emphasizes, Leigh's awe-inspiring formation—the triumvirate of *Panoptica*, *Jug*, and *Sentinel* that she brings into silent conversation with the sonic protection ushered forth by *Loophole of Retreat I*—demands complex forms of labor.

The opacity of these works most certainly requires us (as Rodney rightly emphasizes) "to check our desire for reciprocal recognition," and in turn, to sit uncomfortably with the impulse to transform that discomfort into a form of reflection that is potentially transformative. Yet I would contend that this is not the result of the elusiveness or "incalculability" of these figures. It is not their ability to silence their interlocutors, though as I have written before and will reiterate in the pages to come, Black women's refusal to use words to render the complexity of our interiority is, more often than not, taken as an affront. It is, rather, our capacity to actively create our own gaze—a Black gaze that demands active forms of engagement, rather than passive acts of watching or consumption—that requires the work of

witnessing from its viewer. It is the work of enduring discomfort
and facing it head on. The gaze that ricochets between *Panoptica*,
Jug, and *Sentinel* is a Black feminist formation Leigh constructs
by configuring them as a group formation. As a female *chorus* in
dialogue without words, in concert without instruments, in song
without notes, gazing without eyes, and speaking without voices,
together they create not the hush of silence, but a quiet, disruptive
chorus of subversive Black feminist noise.

. . .

There was a third section of the exhibition that was far less
accessible than the two more prominently visible sections of the
show I had inhabited for close to two hours. But getting to it felt
like following breadcrumbs through the forest. Tiny signs offered
cryptic hints and somewhat counterintuitive directions. Walk up
to the next level in order to go downstairs; take this elevator, not
that one; follow the corridor to the end and wait for the doors to
open at the appointed time each afternoon, thirty minutes before
the screening.

On the day I chose to view the moving image accompaniment to
the exhibition, the projection staff was having technical difficulties
and after ten minutes or so of unsuccessful tinkering, I was
beginning to think I'd head home and would need to return another
day. When they finally managed to get the sound to work in the
basement theater of the Guggenheim, it was immediately clear that
it had been worth the wait.

Simone Leigh, *Untitled (M*A*S*H)* (2018)

She bobs and swings, dips and sways, hops and shuffles. Stoic at
first, a smile washes over her face, blossoms briefly into a grin, then
settles into a restful look of satisfaction. In the opening sequence
of Leigh's 2018 film, *Untitled (M*A*S*H)*, her gaze fixes us with
a steady, unwavering focus. With a tambourine in her hand and
cymbals affixed on appendages initially out of view, the hop, slap,
and wordless shimmer of a joyous Black woman in military fatigues
is slowly overtaken by the swell of a hand-pumped organ. The film
transitions to a solo performance in a cavernous space through the
image of a Black woman rinsing her glistening face.

Simone Leigh, *Untitled (M*A*S*H)* (2018)

Simone Leigh, *Untitled (M*A*S*H)* (2018)

Our gaze shifts to a Black woman clothed in white garments of
medical care preparing for a procedure in the vast warehouse. She
inserts tiny needles with precision into the smooth skin of her
ebony patient. Her methodical, digital labor of painlessly affixing
these delicate tools of healing is hailed by a triumphant musical
refrain—"to be young, gifted, and Black"—zealously delivered
through a curtain of chestnut curls and a glowing smile. Cut to
a mother cradling her wriggling infant in one arm while reading
aloud from a litany of Black manifestos in French. Surrounded by
bodies in fatigues, at first seated upright but later prone, a Black
woman in an anatomically correct bodysuit lays hands on each
person. Cut again to a sweet soprano serenading a patient in an
army surgery with the gospel hymn "Precious Lord." She is flanked
by two fellow caregivers in white, while in the background a figure
leaps intermittently above a surgical screen.

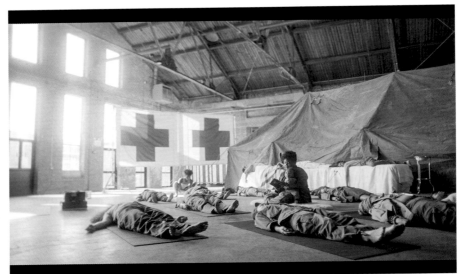

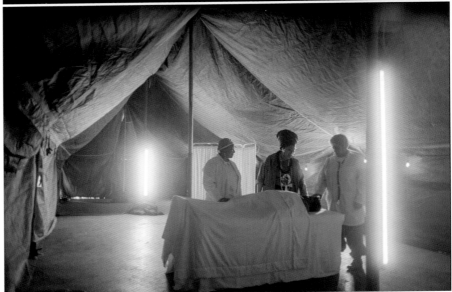

Simone Leigh, *Untitled (M*A*S* H)* (2018)

. . .

Translucent black circles linked in a horizontal chain. Between
each row, we glimpse a lush background of the tangle of vines of
bougainvillea and Spanish moss that signal a southern plantation.
At the center of the frame we see a veiled photographer train his
camera upon the photographic subject through whose eye we view
this scene.

Madeleine Hunt-Ehrlich, *Spit on the Broom* (2019)

A quick cut shifts our view to the markedly different perspective on
the other side of the camera. We see that the subject of the photo
is not the individual whose gaze we embraced in the preceding
frames. The photographer's focus is on a pristine white infant with
shimmering blue eyes, dressed in frilly white booties and matching
white gown, suggesting the family ritual of a christening or baptism.
Seated in front of a mirror image of tangled vines and bougainvillea,
the child is cradled in the arms of a Black woman covered by a
black shroud with an eyelet pattern we recognize from the earlier

frames. In Madeleine Hunt-Ehrlich's 2019 short film, *Spit on the Broom*, the camera's gaze embraces the perspective of Black women in ways that unsettle our expectations.

Madeleine Hunt-Ehrlich, *Spit on the Broom* (2019)

In the tradition of early photographic portraiture, this caretaker's image is not worthy of capture. Despite her labor of surrogate maternity, she is merely a prop relegated to invisibility in the background of an image intended to showcase the pride of white lineage. She is unworthy of our gaze—or perhaps it is the opposite: we cannot withstand the withering force of hers. The scene quickly shifts to a Black man assembling a wood coffin, but it is equipped with breathing holes for the inhabitant of this enclosure. It is an enclosure meant to deliver its charge still breathing. Cut again unexpectedly to an arm that extends from off-screen into a cane field flashing a mirror in the light—is it a warning or a beckoning signal of safe passage?

A recorded reading of announcements heralds the work of a group of Black women sworn to secrecy and dedicated to the mutual aid of one another: the United Order of Tents. They honor the labor of sisters past and present—"sisters whose shoulders we now stand on"—who saw the bend in the road. The women of the United Order of Tents are women who keep secrets. Their faces flash across the screen as the camera lingers on each. Their faces are unique, each inscribed with stories and secrets. They are elders accompanied by their juniors and aspiring affiliates. They capture us with tender but fierce gazes. Regardless of age, they are resplendent with a vibrancy that defies age.

A rush of images flash before us that symbolize this maternal society of care. A Black mother and two daughters exchange looks with a mother wolf and her cubs. Black women's homemade refreshments assembled on a table on a summer day: green molded Jell-O, white cake with daisies, yellow cake with maraschino cherries, green coconut cake. Each signifies the work of adornment and the skill of domestic expertise marshalled for the mutual aid of women united in the labor of care.

Madeleine Hunt-Ehrlich, *Spit on the Broom* (2019)

Madeleine Hunt-Ehrlich, *Spit on the Broom* (2019)

· · ·

*Untitled (M*A*S*H)* **by Simone Leigh** and *Spit on the Broom* by Madeleine Hunt-Ehrlich are two sides of the same coin. Each tells a different version of the story of the United Order of Tents, an organization founded by Black nurses in 1840 to tend to wounded captives fleeing enslavement. Following emancipation, they formed a secret society to provide life insurance for their members to ensure that each would have the dignity of a Christian burial. Leigh's film is a symbolic depiction of the labor of care provided by these women in their battle against enslavement, transported from the US South and reimagined as a group of nurses on a fictional battlefront in the Korean War. Hunt-Ehrlich's film offers a dreamlike retelling of the history of this group and of Black women's alliances for mutual aid. Yet what they share is a representation of the power of women's alliances not only as protective and defensive but also as insurgent.

Although dressed in military khakis or the uniforms of a medical battalion, the women depicted in *Untitled (M*A*S*H)* are neither combatants nor belligerents. Nor are they engaged in the violent overthrow of a government or regime. But the work they do is equally insurgent; it challenges the status quo of leaving their kindred to fend for themselves. These women sing to soothe, prick to heal, lay hands on to calm. They make music and speak manifestos. Configured in circles, triangles, or orderly rows, they assemble in multiples and speak in the voice of collective action. Like the towering chorus of *Panoptica*, *Jug*, and *Sentinel*, who offer a silent commentary on those passing in and out of the gallery like the ambient yet insurgent sonic montage of *Loophole of Retreat I* that perplexed so many

insurgent:

a rebel, revolutionary, or participant in an uprising; participating in an insurrection by a group not recognized as having the status of a belligerent.

visitors in the latticed enclosure, *Untitled (M*A*S*H)* also assembles a chorus—a Black feminist chorus of caregivers as fearsome as any army of men.

In *Spit on the Broom*, Madeleine Hunt-Ehrlich's chorus of The United Order of Tents celebrates these women's collective commitment to caring for women transitioning from bondage into freedom. They are the same women who later transformed their organization from handmaidens of liberation to caregivers pledged to ensure their sisters the dignity of a Christian passing over to a new life by and by. The Tents are a historical analog to Leigh's chorus of caregivers in "Loophole of Retreat," mirroring the triumvirate that watched over the gallery where Leigh recreated the sonic protection of sisters, mother, and child telegraphed from 1978 into 2019 in *Loophole of Retreat I*. The rebellious forms of care and the revolutionary practices of mutuality modeled by the women of the United Order of Tents in the late nineteenth century and practiced later by the incarcerated women who protected Debbie Africa in Cambridge Springs are powerful choral enactments of Black feminist insurgency.

A chorus is a very different formation than the jazz ensemble so often invoked in Black cultural criticism and Black studies. It has neither a leader nor a soloist who steps out to demonstrate individual prowess or autonomous genius. Frequently seen as background to or the supporting cast of the soloist, the chorus is often understood as subordinate to the direction of a "leader." But the chorus is a complex and delicate balancing act. It is a multitude that blends together a diversity of players in seamless harmony. It depends on an intricate coordination of individual voices, dancers, or performers that blend together without erasing its individual members. It holds together and coheres through the mutual support of its participants.

The final scene in *Spit on the Broom* brings the empowering effects of the chorus and its members into fuller view. The scene assembles a group of Black women in nineteenth-century dress gathered to bathe each other's feet in a communal ritual. One transcends this historical setting to reenter in the contemporary moment. She stands before her future self, dressed in matching black robes. And this time it is she who wields the camera.

Madeleine Hunt-Ehrlich, *Spit on the Broom* (2019)

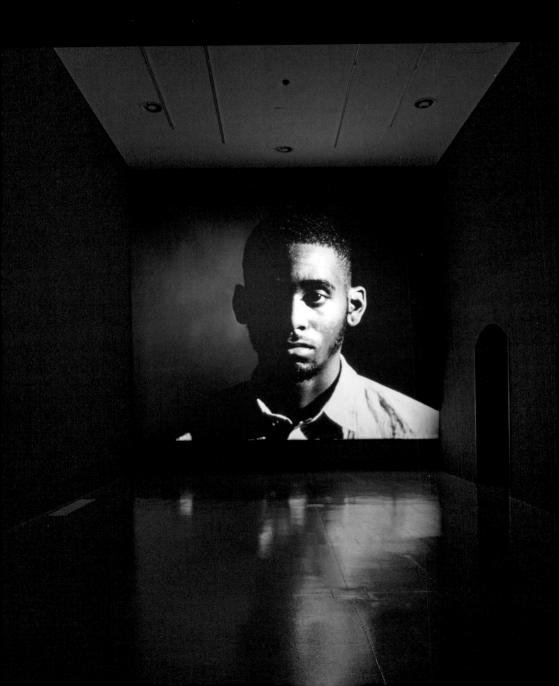

Adjacency and the Poethics of Care

As ever, Luke's question was totally on point: "Are we cursed?" It was a three-word query sent in a flurry of messages we exchanged during a moment of near panic for me at the height of the 2019 European heat wave. From my perspective, it would probably have been more accurate to say "thrice cursed," given the extreme weather circumstances of a series of near-miss encounters that began with our initial meeting at the Berlin Biennale in the previous blazing hot summer of 2018.

We were introduced in the horrifically hot courtyard café of the KW at the Berlin Biennale while attempting to staunch the heat with cold drinks together with the group of melting Black women whose work was installed on different floors of the KW. He mentioned something about celebrating his thirtieth birthday, which surprised me because he struck me as much older. Moments later, I learned the more astonishing news that he had been nominated a few weeks before for the 2018 Turner Prize.

The next day was equally hot and as I climbed the stairs to the top floor of the KW, I was preparing myself for the harsh reality that warm air always rises and, with projectors in the room, I should expect the worst. What hit me first was a wave of heat that hung like a heavy curtain in the room. What hit me next was a wall of sound that was initially difficult to trace. Seeking shelter from the heat, I instinctively moved to the coolest part of the room to reclaim the undervalued real estate I so cherish.

The room was empty except for the massive projector at its center. The projector's sizable scale dominated and intimidated anyone present in the vacuum of the space. Yet, despite its imposing physical presence, its fullest impact was aural and sonic. While the film itself is silent, its visuality is permeated by the rhythmic monotone of a projector that suffuses the space with a rapid mechanical clacking. Its insistent drone amplifies the image it projects and simultaneously engulfs.

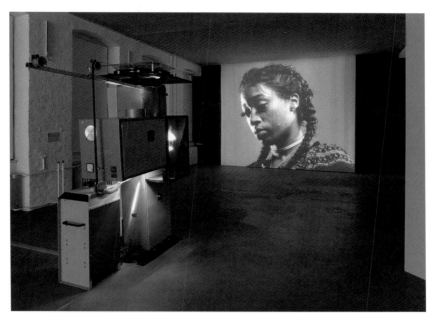

Luke Willis Thompson, *autoportrait* (2017)

The figure on the screen was a Black woman with long braids resting on shoulders covered by a tee shirt. Just below her cropped sleeve, her arm provides the only hint of identification through the tattoo that clads it: Philando. The grainy black-and-white composition of her celluloid figuration gives heightened definition to the sheen of her face, the texture of her skin, and the taut weave of her plaits. Her movements are minimal as her initial photographic stillness transforms into subtle, gentle, and affecting motion. Chin held high looking upward; chin bowed with eyes cast downward; glasses skimming abundant eyelashes; absent glasses reveal soulful eyes. Ebbing side-to-side, adjusting in her seat, nodding occasionally, followed by an effortful in- and exhale. A prayer, a meditation, or an internal monologue made manifest?

autoportrait (2017) by Luke Willis Thompson is a silent portrait of Diamond Reynolds, whose live Facebook broadcast seated in a car next to her partner Philando Castile in the immediate aftermath of his murder by officer Jeronimo Yanez in Falcon Heights, Minnesota, offered a chilling account of one of a seemingly endless series of brutal killings of innocent Black men and women at the hands of law enforcement. Thompson describes it as an alternate response to her remarkable act of witnessing, as a "sister-image" or second broadcast, "where her survivability is the subject of her performance."[1]

Composed of two four-minute takes of Reynolds filmed in April 2017 in Minnesota and shot in 35mm Kodak Double-X black-and-white film, *autoportrait* is irreproducible without consent. It must be viewed in the context for which it was created: a darkened room that demands complete immersion and full attentiveness. Straddling the gap between still and moving images, *autoportrait* was awarded the 2018 Deutsche Börse Prize for photography.

Thompson's sensuous piece has been celebrated and rebuked.
Hailed, on the one hand, as an elegiac reclamation of its subject's
strength, dignity, and humanity, it has on the other hand been
the target of withering attack by detractors who view it as
an aestheticization of Black suffering. Drawing parallels to
Dana Schutz's controversial contribution to the 2017 Whitney
Biennial, *Open Casket*, Thompson's critics echoed Hannah Black's
condemnation in her open letter to curators and staff where she
argued that "non-Black artists who sincerely wish to highlight
the shameful nature of white violence should first of all stop
treating Black pain as raw material."[2] Citing Schutz's example, Nick
Scammell protested, "Reynolds is known because she refused to be
silenced. Yet *autoportrait* sees her both speechless and distanced
into black and white film. . . . Detached. Disconnected. Inert."[3]

As a mixed-race New Zealander of Fijian heritage, Thompson
has described himself as a Black artist, albeit not of the African
Diaspora. It is an attribution I take seriously as
positioning him in a place of *adjacency to* rather
than identity with the forms of anti-Black violence
his piece so poignantly evokes. It is the adjacency
of indigenous and diasporic peoples linked by
a vicious history of imperialism and colonization
that tethers Black subjects to Pacific Islanders.
It is the adjacency experienced by Diamond
Reynolds, sitting next to her partner in a car and
witnessing his murder with her three-year-old daughter trying to
comfort her from the backseat (*"It's okay, Mommy, it's okay. I'm
right here with you."*), and having the composure to attempt to talk
down the officer who shot him, while capturing it on a cell phone
and broadcasting it to the world to bear witness to both her loss
and her refusal to silence his slaughter.

adjacency:

the reparative work of
transforming proximity into
accountability; the labor
of positioning oneself in
relation to another in
ways that revalue and
redress complex histories
of dispossession.

While she never eyes us directly, the Black gaze of Diamond Reynolds captured so powerfully in *autoportrait* demands quiet yet arduous affective labor. It demands we partake of the labor of adjacency, which requires us to listen attentively to her quietly enthralling image and feel accountable to it. As Scammell rightly emphasizes, Reynolds's act of defiance was her refusal to remain silent. Yet *autoportrait* renders her neither speechless nor silent. In Thompson's carefully constructed, still-moving-image, Reynolds delivers a quiet but devastating critique that wrests our undivided attention.

In each of the preceding verses, I've offered different insights into the power and possibilities of a Black gaze. This verse extends these reflections with an important clarification: a Black gaze does not describe the viewpoint of Black people. It is not a gaze restricted to or defined by race or phenotype. It is a viewing practice and a structure of witnessing that reckons with the precarious state of Black life in the twenty-first century. A Black gaze transforms this precarity into creative forms of affirmation. It repurposes vulnerability and makes it (re)generative. The Black gaze that emerges in *autoportrait* does not position white spectators as the subjects of its gaze. It is a gaze that reconfigures the dominant gaze by exploiting white exclusion from and vulnerability to the opacity of blackness. In doing so, it demands forms of affective labor that implicate and impact its viewers.

Black gaze:
a framing that positions viewers in relation to the precarity and possibility of blackness; a gaze that requires the affective labor of adjacency.

autoportrait does not grant us access to Reynolds's interior world; it challenges us instead to do the work of feeling beyond the satisfaction of identification with someone less fortunate, less secure, or utterly precarious. Thompson's Black gaze demands instead that we feel the discomfort of being better off and confront it head on. We must feel beyond the security of our own situation and cultivate instead our ability to confront the precarity of less valued or actively devalued individuals, and do the ongoing work of sustaining a relationship to those imperiled and precarious bodies.

Thompson and Reynolds's collaborative portrait of refusal—a refusal to be silenced or to accept the status of Black disposability—is amplified by a refusal to accept words or speech as either adequate or commensurate to the gravity of Reynolds's loss or the monumentality of the crime of devalued Black life. *autoportrait* forces us to engage with a Black woman who overwhelms us through her reserve and control. It forces us to reckon with the everyday labor that Black women have mastered since captivity—carrying loss with dignity, mourning in plain sight, and at the same time, refusing to capitulate to the mundane regularity of premature Black death.

refusal:

a rejection of the status quo as livable by creating possibility in the face of negation, i.e., a refusal to recognize a system that renders you fundamentally illegible and unintelligible; rejecting the terms of diminished subjecthood with which one is presented and embracing negation as a creative strategy for living otherwise.

Truth be told, a silent portrait of any Black woman is categorically unbearable. Our refusal of words is inevitably embraced as an invitation to impose a narrative we have neither authored nor authorized. Set against the backdrop of the story Diamond Reynolds refused *not* to tell—Why do we demand to hear her tell it again? Why do we expect or insist that she repeat it or tell it differently? Why is this account of it, without words or speech, delivered instead through subtle gestures that have an affective power that exceeds words, not enough?

We must ask ourselves why it is so discomforting to have to listen to what we are seeing, and in doing so, to be accountable to the affective labor of connecting across Reynolds's quiet to engage that which exceeds words. We must consider the even more discomforting fact that Thompson's decision to strip down our encounter with Diamond Reynolds (and by proxy, our encounter with Philando Castile and the murder that Reynolds allowed us to witness alongside her) to a monochromatic, quiet encounter with Black death and her refusal to accept it might in fact be utterly appropriate. For the real question it and its critics pose is: what script, words, speech, or text would have been commensurate?

Ultimately, the quiet, still-moving-image of Diamond Reynolds's refusal to embrace silence is, to me, a powerful means of reckoning with the impact of the ongoing war currently being waged against Black bodies. It is a still-moving-image of refusal—a quiet refusal to explain, a refusal to capitulate, a refusal to be anything else than who we are, even at the cost of death.

．　．　．

I need to return to the threefold weather curse with which this verse began. Fast-forward to June 2019. I was giving a lecture in Nottingham and was delighted to receive a message that Luke was planning to take the train up from London to attend. Three hours later I received another update: "I was supposed to be there around 3 pm but now have no idea when I'll arrive." The message was accompanied by a photo of flooded tracks on the side of a train. As in LA six months earlier, I had arrived during a week of historic rains and flooding, this time in the UK. "Where exactly are you?" I texted. His response was even more concerning: "Somewhere in a ditch between London and Nottingham. They've evacuated the

train." Around 2 am he messaged me that he had finally gotten home. It had been a twelve-hour circular journey to nowhere. But it turned out to be a curse that worked both ways . . .

Two weeks later, most of Europe was buckling under the vicelike grip of what now seems an annual heat wave. Having experienced this in Berlin in 2018, I anticipated it, but had no intention of being in Italy as it neared its peak. Yet the opening of Luke's solo show just outside Milan was an opportunity not to be missed. I had decamped a week before to a modest town just west of Marseilles to avoid the stifling heat of Paris, so Milan was just a ninety-minute hop away. Why not? I thought. Why not, indeed . . .

Within thirty minutes of landing at Milan-Malpensa Airport (where, upon touchdown, it was ninety-nine degrees!), I lost my phone, the cash I had just withdrawn from an ATM, and all of my credit cards. Sixty minutes later, after cajoling my way onto the train, I was stranded on the Malpensa Express into the city due to a disabled train, and a forty-five-minute ride morphed into three and a half hours of misery on an un-air-conditioned train ride into the city. I had texted Luke midway through the ordeal and his responses (including the above-mentioned invocation of a mutually shared curse) almost single-handedly kept me from falling apart.

Silver lining: in a supreme stroke of divine intervention, shortly after checking into my Airbnb magnificently deflated and bordering on tears, I checked my email only to read that a Good Samaritan had found my phone, cash, and cards, and had deposited them at the Carabinieri station near his home an hour north of Milan. Long story short: yes, Mr. Thompson, we are indeed cursed.

■ ■ ■

The projector was even more immense at the show in Bergamo, and the space was twice as large. "Hysterical Strength" at the Gallery of Modern and Contemporary Art was a masterful installation of four of Thompson's most powerful works: in addition to *autoportrait* (2017), *Cemetery of Uniforms and Liveries* (2016), *_Human* (2018), and a newer work entitled *Black Leadership* (2019). As before, the whirring of the projector beckons you in and envelopes you when approaching the space. Yet in the course of viewing, its frequency evolves into background ambience rather than foreground noise. It functions as both an accompaniment and a companion to the images whose presence looms so large in the room.

When I hear news of a hitchhiker
struck by lightning yet living,
or a child lifting a two-ton sedan
to free his father pinned underneath,
or a camper fighting off a grizzly
with her bare hands until someone,
a hunter perhaps, can shoot it dead,
my thoughts turn to black people—
the hysterical strength we must
possess to survive our very existence,
which I fear many believe is, and
treat as, itself a freak occurrence.

—Nicole Sealey, "Hysterical Strength"[4]

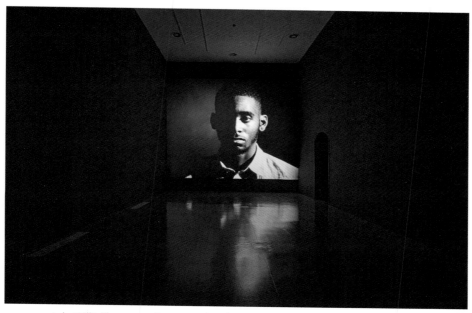

Luke Willis Thompson, *Cemetery of Uniforms and Liveries* (2016)

Brandon, grandson of Dorothy. He is the younger of the two men who confront us eye to eye in *Cemetery of Uniforms and Liveries*. The left side of his face is hidden, cloaked by a dark, unyielding shadow. His only movement is the infrequent bob of an Adam's apple, suggesting a reflexive swallow to lubricate the throat of this relentlessly still figure. His lack of movement is so profound it could easily be mistaken for a projected still image were it not challenged by the sound and sight of film moving through the projector that serves as its origin. He almost never blinks. Indeed, watching him is like an anxious game of chicken that finds you willing his next blink into fruition.

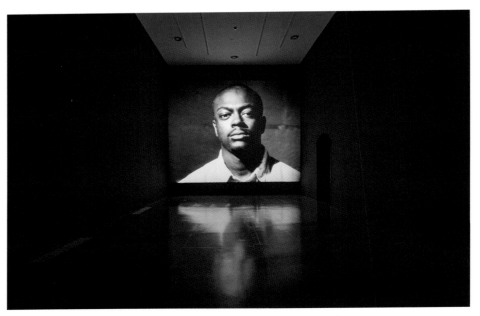

Luke Willis Thompson, *Cemetery of Uniforms and Liveries* (2016)

Graeme, son of Joy. Like his filmic sibling, the expressionless direct
gaze of this second man is also held for five endless, uncomfortable
minutes. His face is illuminated more fully than the other's, as
a slim crescent of shadow rests lightly on his right cheek and
forehead. Like Brandon in the image that precedes him, Graeme's
movement is scant, albeit more easily perceptible. It is a slow
blink that, once completed, subtly transforms his expression as his
eyes narrow into what becomes a quiet, probing glare. The effort
required by his diligent intention not to move is evidenced by a
periodic flutter of the eyelids, which seem to strain at being held so
unnaturally long ajar. His only other movement mirrors his sibling
filmic figure when his lower lip retracts reflexively to moisten a dry
mouth produced by prolonged stillness.

Each of these twinned 16mm black-and-white portraits are
single takes of two Black British men who lost maternal figures
at the hands of London's Metropolitan Police. Cherry Groce,
grandmother of Brandon, was shot in 1985 and died later of
complications from her injuries in 2011. Her shooting triggered the
Brixton riots of 1985. Joy Gardner, mother of Graeme, was killed in
her home in 1993, when officers attempting to arrest and deport her
gagged her by wrapping thirteen feet of surgical tape around her
head and face. Unable to breathe, she suffocated and died four days
later of cardiac arrest.

While the filmic techniques that so powerfully frame Brandon
and Graeme intentionally replicate the formal qualities of Andy
Warhol's iconic series *Screen Tests*, they produce a very different
gaze than the celebrity-hungry white gaze of their predecessor.
They expose us to the unrelenting, full-on gaze of Black loss that
inverts the gaze of the camera, by requiring us to be looked at and
scrutinized. The film challenges viewers to reflect in the absence of
words on what its protagonists might be thinking, feeling, or seeing
in us. It requires us to stand still and dare to be looked at, and to
hold and return the gaze of trauma of another. In doing so, they
refuse to allow us to look away.

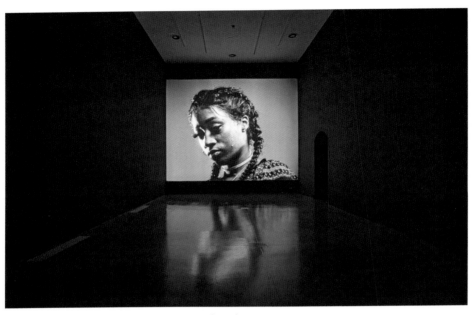

Luke Willis Thompson, *autoportrait* (2017)

Diamond, partner of Philando, mother of Dae'Anna. Viewing her again in the context of "Hysterical Strength," the differences between Diamond Reynolds and her fellow members of this unlikely chorus of witnesses to Black negation register initially through mundane and minute details. She is adorned with carefully chosen objects: a sparkly choker, a chain dangling around her neck, lip gloss, earrings, eyeliner. Unlike the men featured in *Cemetery*, she is not still. She blinks frequently. She moves sparingly, but regularly. She breathes visibly, heavily, with the weight of deep reflection.

Unlike her Black British kindred in grief, she does not look into the camera. She refuses our gaze and directs it elsewhere instead. Her wistful half-smile tells us that despite her willing participation

in the filmic dialogue in which we now partake, her interlocutor was never intended to be us. When she mouths words we cannot hear and wags her head rhythmically; when she closes her eyes, pauses, presses her lips together, as if to hum—we must ask not what words does she speak, but what words would ever suffice? The adjacency we experience through Thompson's *autoportrait* of Reynolds forces us to ask not to whom is she speaking, but what gives us the right to be privy to a monologue whose grief so fundamentally exceeds words?

. . .

No silent portraits, no steely, uncomfortable gazes; in fact, no people at all—or at least none immediately recognizable as such. But his presence looms equally large, even lacking figural embodiment. His quiet is equally loud, and his refusal to be silenced or erased is equally profound . . .

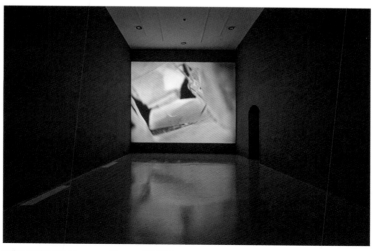

Luke Willis Thompson, _Human (2018)

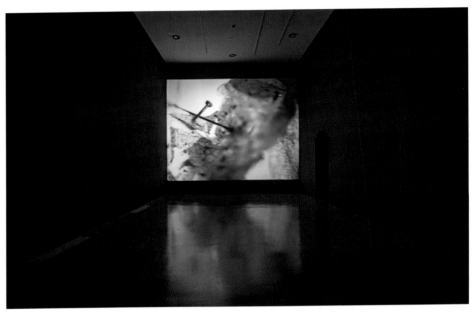

Luke Willis Thompson, _Human (2018)

The camera moves our view along a rough, flaky, flesh-toned surface, then upward toward a blurry jagged pinnacle. It pauses to linger on crossed metal spikes captured and contained by the same flaky substrate. We emerge inside revolving walls, gazing upward at its apex. Viewed from this angle, the crossed spikes are now recognizable as pins tethering walls within the fragile structure. The camera zooms in and out, telescoping between different perspectives that render what was initially small, larger and clearer, slowly revealing its full, albeit miniature, dimensions and proportions in haunting detail.

A tiny house made of human skin flanked by two satellite structures constructed of the same material—a still life of epidermal domiciles. The metal pins we have viewed puncture and at the same time suture them together. They secure the structure while simultaneously wounding and piercing it, in the film's wordless silence. Our view shifts abruptly again as we are plunged into a darkness punctuated by shimmers and flickers of light. These pinholes of illumination reveal glimpses that confuse and confound.

Luke Willis Thompson, _Human (2018)

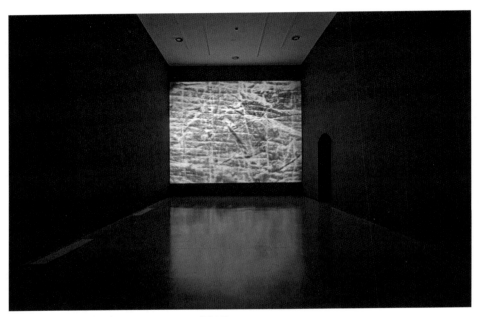

Luke Willis Thompson, _Human (2018)

Each fragile house has the texture of paper dotted by spots and lines. As the camera toggles yet again, the structures are spun around and shown from multiple angles. As they revolve around and around in a cascade of three-dimensional vertigo, we see their crisscrossing lines of frailty differently—as the residual impression of tiny capillaries that signal the weave of life that marks this tissue even in the absence of the fleshly being it once encased.

Watching the film and allowing it to engulf me in its cascading perspectives, I raised my hand to observe my own skin alongside it to see that our surfaces share similarities while being markedly distinct. Doing so highlights the different textures not only of our respective living or lifeless skin; it highlights as well a shift in the texture of the film itself. While it begins with the sharpness of high definition, along the way it transitions to mimic the grainy texture of archival film. But what it archives is even more complex than the intricate domiciles it captures.

Thompson's 2018 35mm film _Human is an almost molecular documentation of Donald Rodney's delicate sculpture, *My Mother. My Father. My Sister. My Brother* (1996–1997)—a miniature house measuring merely a few centimeters and made from Rodney's fragile skin grafted during his hospitalization for sickle-cell anemia. The tiny house he constructed of his own skin mirrors the equally frail body in which Rodney was forced to live, as well as what Eddie Chambers describes as the futility of "having to live within a structure hopelessly unable to sustain itself." Chambers continues: "and yet, concurrently, the house resonated with defiance, a curious strength, and comforting notions of 'home.'"[5]

_Human archives Rodney's artistic documentation (both as sculpture and in his 1997 film *In the House of My Father*) of his body's battle with a hereditary blood disease that afflicts Black communities. Yet Thompson also encodes the adjacency of his own family history of hereditary disease into the mechanical structure of the film, which incorporates his siblings' (and potentially his own) status as genetic inheritors of Huntington's disease by using their genetic repeat count as a template for the number of film strips used in editing the film.

_*Human* instantiates the tensions of adjacency by comingling two very different hereditary illnesses—one that affects the Black community and another that Thompson has potentially inherited from his white mother. In doing so, it positions them in a relation of proximity and vulnerability that revalues both Rodney's suffering and his creative practice. But the question remains, why archive the dissipated or dying Black body in a work of art? And why inscribe a potentially fatal genetic inheritance into the archival doubling of a work of art reflecting on the dying body of a Black artist? _*Human* enacts a dialogue of adjacency with Rodney's piece as a practice of quiet witnessing. It is a quiet yet imaginative reflection that refuses to embrace death passively by insisting on a visual presence in the archive of the future that projects him forward in time. And it is a defiant refusal of the Black gaze to ever accept erasure.

. . .

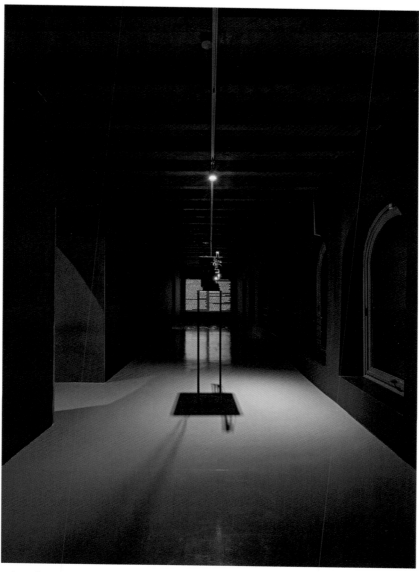

Luke Willis Thompson, *Black Leadership* (2019)

Luke Willis Thompson, *Black Leadership* (2019)

In a second gallery adjoining the first, a textual supplement screens alongside the looping still-moving-images in the main gallery. When I entered the space, I felt my depth perception rapidly fail. As I approached to read its content more clearly, a profound sense of vertigo gripped me as I pitched left and reached for the wall to steady myself. *Black Leadership* is disorienting in its three-dimensional depth. The text flickers and floats as if suspended in air rather than projected onto the wall. It is the artist's own quiet but deeply resonant rejoinder to many of the questions I have posed thus far.

The floating text is a letter addressed to an art journal editor. The letter is pointed and direct. It urges reflection on comments published in the pages of the journal and demands recognition of their destructive force. Profiteering is the withering accusation to which the letter's author, Thompson, responds: profiting from art that exploits Black pain and suffering. But is it profiteering, or a refusal to be mute? Is the silent but searing presentation of the trio of witnesses in *autoportrait* and *Cemetery of Uniforms and Liveries* an act of exploitation, or is it, as I would argue, an act of refusal?

Dear Editor,
We have actually met in passing and share some mutual friends in the artworld, but I'm writing to you now as I'm deeply disturbed by your short online article entitled "BLACK PAIN IS NOT FOR PROFIT: ACTIVISTS PROTEST LUKE WILLIS THOMPSON'S EXHIBITION". This article appears to be a reworking of markedly similar news items that ran on numerous art sites regarding a protest staged by a London-based collective at Tate Britain. I was of the opinion that your art magazine had different critical criteria from these news sites. These fail all standards of ethical responsibility and even took the staggeringly insensitive action of contacting Ms. Reynolds herself (not her lawyer, nor her media representative) for a comment on "the profiting from black pain". Consider how easily and logically she could assume the tacit implication that her civil settlement was undeserved. Diamond Reynolds herself has been extensively criticized online for trying to 'profit' from her tragedy, predominantly by hate groups and white supremacists. In the weeks since the opening of the Turner Prize 2018, I've been repeatedly asked to comment on such questions as, "Is Willis Thompson (sic) aware of the protest? How does he respond to the criticism that he is profiting from the pain and death of black people with his work?" How can I genuinely respond without knowing how the questioners, who write semi-anonymously from behind corporate brand identities, themselves value black life? Or whether, and how, the concept of blackness evoked in the question is evaluated prior to its asking?

The work, that is more painful than you know, has led to this exposure, which means that at some stage I'll likely profit from all the media attention. But what alternative do you propose? How do I remove myself from the structures and systems of the art market—the one you exist for—and still manage to make and exhibit work I believe in and in the manner that I choose? How do I exist in this artworld without becoming a persona to be speculated on? Do you know that the property values in the Falcon Heights area where Philando Castile was killed went up following the shooting? Do you know that Zimmerman, the person who killed Trayvon Martin, later auctioned the very firearm that he used to assassinate him? Can you imagine what it means to be compared to these forms of profiteering?

Like all mixed-race peoples, I have an ear well-tuned to the linguistic nuances of racialist calculation.

I understand too that this accusation is not really about how I feel, or about the artwork itself, but more to do with which strategy I decide to adopt to fight the charge, based as it is on how you render my appearance as whiteness. Which brings me to what I find so vulgar in your story: the perpetuation of the term 'white-passing' in reference to my person. While the protesters feel comfortable using that term, to have it re-quoted by your magazine is frankly inappropriate. The term 'passing' relates directly to global colonial history. Its casual deployment in popular magazines like yours only furthers its exploitation for the purpose of racist, culturally xenophobic gerrymandering. When used by white people, or white institutions (which it has been frequently of late) it is a worrying denial of the realities of systemic racism and of how race impacts on a person's life through their family, community, and clusters of inherited characteristics that in turn help to determine their wellbeing.

That I've supposedly 'passed' in your eyes means nothing to that which flows beneath my skin or circulates within my selfhood.

Moreover, so contorted does your clinical description of my ethnicity sound against the cymbal-like clarity of 'white passing's' repeated use in your article, that it presents me in a manner similar to the one put forward by the protestors: as a racial traitor and imposter. As a result of simplistic news articles like yours, some visitors will adopt an antagonistic or punitive stance towards my work, and most will be white. How righteous do you suspect their motivations and anger will be?

Dear Editor,
I'm inclined to believe your treatment of the story is not at all in the service of black thought and humanity but is simply a contemporary form of click-based race-baiting. If I were to take my own life, like Thabiso Sekgala did, or seek a "death commensurate with bourgeois achievement and political awareness" as Margo Jefferson aspired to, or else simply replicated the poetics of Capital Steez who typed "end." into the ether, I'd ask you to be more precise in finding a name for what it was that killed me. And to remember to ask: who profited?

Luke Willis Thompson, *Black Leadership* (2019)

I must answer, predictably, that it is the latter. It is a refusal to
be complicit in the silencing of Black pain and suffering, and a
simultaneous refusal to impose words on the indescribable. It
is a refusal to depoliticize the space of the gallery or to assume
the art world is removed from the politics of Black fungibility.
It is a refusal that forces us to do the work of reckoning—both
inside the gallery and beyond it—with our own culpability in the
infrastructures of anti-Black violence that pervade *every* space,
regardless of whether we acknowledge it or not.

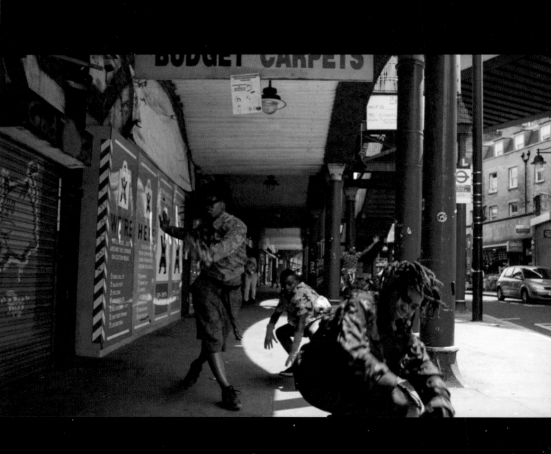

The Haptic Frequencies
of Radical Black Joy

Her chorus is markedly different but intimately linked. It is framed neither by the serial assaults on Black life, nor the disposability of Black bodies. Its frequency registers through the ecstatic, irrepressible movement of Black bodies. The haptics of Jenn Nkiru's *Rebirth Is Necessary* (2017) are not those we perceive through the tactile sensations of physical contact. They are not the haptics of touch; they are the haptics of feeling.

haptic images:

images that touch and move us not simply through what we see; affective images we respond to viscerally; images that solicit multiple sensory responses.

And the frequencies of this remarkable, refreshing, and resounding work—both in spite and because of its exquisite constellation of soundtracks and soundscapes—are not those we encounter with our ears. They are not the frequencies we usually associate with the sublime organization of sound we define as music. They are the visceral frequencies that resonate in and through us as participants and witnesses. The haptic frequencies of *Rebirth Is Necessary* register through the indelible impressions it leaves upon us when we dare to open ourselves up and make ourselves vulnerable to the impossible possibility of a rebellious and insurgent embrace of *radical Black joy* . . .

. . .

Hearing it gripped me as intensely as it did seated at the foot of
Simone Leigh's ceramic tangle of cornrows: a Black girl clap-slap-
song-play. Arriving in this instance midway through the film, it was
sonically intertwined with the singing of a repeated refrain—"Black
is beautiful." As it fades to silence, another voice rises to chant a
powerful affirmation:

> *We are: soldiers-for-the-Nation-of-Islam.*
>
> *Mission: to-save-the-blind-deaf-and-the-dumb . . .*

Jenn Nkiru, *Rebirth Is Necessary* (2017)

Jenn Nkiru, *Rebirth Is Necessary* (2017)

Elegant blue uniforms with knee-length gabardine jackets paired with long skirts or slacks. Matching head scarves and heels, a military cap, insignia, and badge: "Vanguard." They are a militia of lady soldiers in lockstep.

Jenn Nkiru, *Rebirth Is Necessary* (2017)

Shuffle, step, salute; shuffle, stomp, turn.

Eyes left, elbows lifted, gloved hands land precisely at the brow.

Eyes trained straight ahead at attention; turn again, salute.

Stomp, turn, salute; stomp, turn, salute;

repeat with precise coordination.

Their synchronized movement ceases abruptly as they come to rest in a stillness framed by the soundscape of the continued rhythmic rumbling of their stomping feet, which fall immediately silent to the words of a military benediction: *"Sisters, fall out!"*

. . .

A brown girl in a baby-blue dress dances intently with a slightly smaller, slightly younger, little lady in white. In the background we glimpse a delighted pair of musicians creating the original soundtrack to their improvised choreography. Their faces gleam as they take in the beauty of the scene. Surrounding them we see a roomful of onlookers. Seated, standing, or straddling the two, they huddle together watching, transfixed and elated by the dancing pair's complete absorption and utter obliviousness to the spectacle they have created.

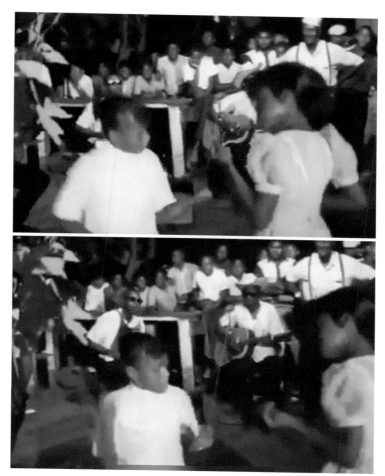

Jenn Nkiru, *Rebirth Is Necessary* (2017)

Their heads bob and wag.

Their tiny bodies pulse and wiggle.

Their arms pump up and down and back and forth.

Together they synchronize in a rhythmic duet

that draws us closer and closer (in)to the screen.

As the music rises and its intensity increases, the scene shifts
to juxtapose our dancing brown girls with the backward leaps,
waving arms, and exaggerated steps of fly Black dancers in an
urban cityscape. We encounter them through a filmic rewind that
reverses time and defies gravity. As their dreads and braids flail
upward and outward, crowning expressive faces, they strike a vivid
contrast to the carefully coifed press-and-curl of our two brown
baby girls whose hair never moves out of place. The camera segues
from this glorious duo to our band of urban dancers to a trio of
praise singers in choir robes and back again to our militia of lady
soldiers in light-blue uniforms. They merge as a chorus of Black
bodies rejoicing in motion. All the while, a kinky-haired, blue-Black
angel chuckles while levitating above stilled blue waters.

Jenn Nkiru, *Rebirth Is Necessary* (2017)

Jenn Nkiru, *Rebirth Is Necessary* (2017)

Black bodies rock and sway in couplets of male and female, male and male, female and female, single women, men, and groups of frolicking children. They move exuberantly to music they hear but we do not. The soundtrack we hear is not their soundscape, but it

does not matter, for their movement is a dance of rejoicing and jubilation. The rewound reversal initially rendered through the lens of filmic editing is now enacted by the dancers themselves, who flex themselves into postures, poses, and contortions we feel as much as we see. It is a depiction of Black flow—the countergravitational capacity of Black folks' ability to defy the deadly downward pull of white supremacy. It is a defiant refusal to capitulate or be subdued. What is their frequency?

It is the frequency of Black awakening.

It is the frequency of radical Black joy.

Rebirth is necessary.

Acknowledgments

This book is in many ways a chronicle of a journey. It was not a journey I embarked upon knowingly, but one that carried me and buoyed me through difficult times. It was a journey that schooled me in the making of art and the transformative practices of artistic thinkers. And it is to them that I owe an enormous debt of gratitude.

My deepest, heartfelt thanks to Deana Lawson, Kahlil Joseph, Arthur Jafa, Okwui Okpokwasili, Dawoud Bey, Simone Leigh, Madeleine Hunt-Ehrlich, Luke Willis Thompson, and Jenn Nkiru for showing me the power of art to change how we see the world, for seducing me into embracing its joys and confronting its cruelties, and in the process, for teaching me how to reimagine the future. So many of you have become friends along the way, and they are friendships that I cherish. Thank you for opening your minds to engage with me, for your generosity in sharing your work, and for your consistent support throughout the process of writing about it.

I am equally indebted to a group of friends, scholars, and fellow conspirators who provided me with the conceptual tools to do this work and the fortitude to realize its fullest potential. They are the dear confidants and collaborators who comprise my fierce and fabulous intellectual comrades in the Practicing Refusal Collective: Saidiya Hartman, Christina Sharpe, Denise Ferreira da Silva, Tavia N'yongo, Deborah Thomas, Kaiama Glover, Hazel Carby, Alexander Weheliye, Darieck Scott, Rizvana Bradley, and Mabel Wilson. Your stimulating work, our satisfying conversations, our raucous dinners, our deep-throated laughter, our lively debates, and our wayward travels over the past five years have fed and sustained me, and I am all the richer for them.

A special thanks goes to my dear friend Martha Friedman, who held my hand in the bumpy transition to writing about art. Unbeknownst to you, you gave me the courage to think my way into the world of art, taught me what it means to make art, and to understand it in its fullest and deepest complexity. I am also indebted to Doris Gassert of the Fotomuseum Winterthur, whose invitation to write a series of entries for the museum's blog was the experiment in narrative that eventually became this book. And a hearty thanks to the curatorial genius of Gabi Ncobo for bringing together so many incredible artists of color at the 2018 Berlin Biennale, which served as the unwitting kick-starter for the journey that became this book.

I must acknowledge as well my gratitude to the organizations that have provided me with the administrative and institutional succor I needed to complete this project. The Barnard Center for Research on Women and the incredible administrative team of Pam Philips, Tami Navarro, Avi Cummings, Hope Dector, and Che Gossett were my personal "Justice League" of super heroes, hell-bent on

transforming the world into a better place. They gave me the fuel that propelled me to think about the possibilities for living otherwise when nothing else seemed possible.

The Columbia University Institute for Ideas and Imagination in Paris gave me a refuge to think and write when I needed it most, and the beloved members of the D.O.C. ("the dining out club," composed of my fellow II&I Fellows: Bob O'Meally, Tash Aw, Nellie Herman, and our irrepressible canine companion Baxter) founded during that wonderful year made it a space full of joy and laughter and sublime dining pleasure. Paris was also a place that allowed me the opportunity to benefit from the incredible insights, courage, and fearlessness of Françoise Vergès and Maboula Soumohoro, whose abiding influence is woven into these pages.

The Visual Identities in Art and Design Research Centre (VIAD) at the University of Johannesburg gave me the gift of an affiliation as a research associate that opened an entire world to me through a series of ongoing collaborations with South African artists, curators, writers, thinkers, and makers who have transformed my understanding of the meaning of transnational dialogue. I am so grateful for the support of James MacDonald, Amie Soudien, and most of all, my research assistant in Jo-burg, the amazing Nikita Keogotsitse. Without Nikita, this book might not have made it into your hands.

I cannot end these acknowledgements without thanking my agent, Alison Lewis, who sought me out and actually told me what this book was about. She saw it in its infancy as unorganized shreds of unfinished thoughts and recognized what it could be long before I did. She saw and believed in its potential well before this was ever clear to me, and championed it and me throughout the process. Hazel Carby and Saidiya Hartman did what they always do: read

these pages over and over, listened to my doubts, held my hand, tolerated my whiny insecurities, and told me to keep going and never stop. They shaped it like clay and kept my eyes on the prize.

Finally, I must thank the two prongs of my personal support system over this last extremely challenging year. One is the anchor of my life, William Nitzberg. Stalwart, unflappable, a man who makes Job look ill-tempered and impatient—I am so grateful to have you in my life and by my side. The other is the three-woman mutual-aid society that kept my head above water throughout the pandemic through our weekly Zoom meetings: Saidiya, Simone, and Okwui. Ladies, we did it. We held each other through the depths and came out on the other side. Three words: Black girls rule!

Notes

Prelude to a Black Gaze

Parts of this chapter appeared in my article "The Grain of the Amateur," *Third Text* 34, no. 1 (2020): 37–47.

1 I am grateful to Jacqueline Nassy Brown for illuminating this important contextual framework.

2 Tina Campt, *Image Matters: Archive, Photography, and the African Diaspora in Europe* (Durham: Duke University Press, 2012), 44.

3 Laura U. Marks, *The Skin of the Film: Intercultural Cinema, Embodiment, and the Senses* (Durham: Duke University Press, 2000), 185.

4 I am indebted to Michael Gillespie for helping me clarify this important distinction in his thoughtful comments on the manuscript.

5 Jacques Lacan, *The Four Fundamental Concepts of Psycho-Analysis*, edited by Jacques-Alain Miller and translated by Alan Sheridan (New York: Routledge/Taylor and Francis, 2018), 101. My thanks as well to Jamieson Webster for pointing me to delve deeper into Lacan's thinking.

6 I am grateful to Leigh Raiford for sharing this insightful formulation of this dynamic in her careful review of the manuscript.

7 Christina Sharpe, *In the Wake: On Blackness and Being* (Durham: Duke University Press, 2017), 14.

8 "I Was That Alien: Filmmaker Arthur Jafa in Conversation with Hans Ulrich Obrist," *032c*, June 26, 2017, https://032c.com/arthur-jafa/.

Verse One

1 See Laura Mulvey, "Visual Pleasure and Narrative Cinema," *Screen* 16, no. 3 (Autumn 1975): 6–18, for this seminal definition of the gaze. See also bell hooks, "The Oppositional Gaze: Black Female Spectators," in hooks, *Black Looks: Race and Representation* (Boston: South End Press, 1992), 115–132, reprinted in *Movies and Mass Culture*, ed. John Belton (New Brunswick, NJ: Rutgers University Press, 1996), 247 (subsequent citations of hooks's essay refer to this edition); and Manthia Diawara, "Black Spectatorship: Problems of Identification and Resistance," *Screen* 29, no. 4 (Autumn 1988): 66–79, for two of the most influential critiques of the concept of the gaze from the perspective of Black studies.

2 Here again, my thanks to Michael Gillespie for making this important point in an early reading of the manuscript.

3 hooks, "The Oppositional Gaze," 247.

4 Diawara, "Black Spectatorship," 72, 75–76. In "The Oppositional Gaze," hooks famously takes issue both with Diawara, for his dismissal of identification aligned with gender differences for Black women and men, and with Mulvey, critiquing the limitations of Mulvey's definition of the gaze.

5 It also bears noting that in their early work both Diawara and hooks, as well as feminist film theorists like Mulvey and Kaja Silverman, locate the possibility for escaping or circumventing the dominant gaze only outside of mainstream Hollywood studio production, specifically in the work of independent cinema. While the artists explored in these pages are certainly independent artists

whose work is not dependent upon the studio system, their global prominence and, with it, their influence and cache within the art world challenge us to consider what counts in the contemporary moment as "independent" when the circulation of capital is part and parcel of the success of independent artists.

6 See hooks's essay "Eating the Other," in hooks, *Black Looks* (Boston: South End Press, 1992), 21–39.

Verse Two

1 Hilton Als, "The Black Excellence of Kahlil Joseph," *New Yorker*, November 6, 2017.

2 Christina Sharpe, *In the Wake: On Blackness and Being* (Durham: Duke University Press, 2017), 106.

3 My concept of Black countergravity is in direct dialogue with Kathryn Yusoff's articulation of countergravity as a state of suspension between fungibility (enforced precarity and disposability) and fugitivity (embracing placelessness as a refusal to be captured). Building on Dionne Brand's poetic yet unequivocal insistence that for Black women, "The problem was gravity and the answer was gravity," Yusoff proffers a notion of countergravity that renders the Black body "invulnerable, held in the possible, awaiting a different tense of being." As she writes: "the black woman held in countergravity expands the dimensions of geologic force through a different tense of possibility and relation to the earth. Rather than being framed in the 'vexed genealogy of freedom' that forged the liberal imagination through 'entanglements of bondage and liberty' (Hartman 1997, 115), she is partaking of a different gravitational opening, in Césaire's ([1972] 2000, 42) words, 'made to the measure of the world.'" Kathryn Yusoff, *A Billion Black Anthropocenes or None* (Minneapolis: University of Minnesota Press, 2017), 99.

4 Larry O'Dell, "All-Black Towns," Oklahoma Historical Society, n.d., accessed September 17, 2020, https://www.okhistory.org/publications/enc/entry.php?entry=AL009.

5 "10 Most Dangerous Housing Projects in Los
 Angeles," *United Gangs* (blog), n.d., accessed September
 17, 2020, https://unitedgangs.com/2017/01/16/
 the-10-most-dangerous-housing-projects-in-los-angeles/.

6 As with *4:44*, I hesitate to reduce *Until the Quiet Comes* to the genre
 of "music video," as it too does not strictly conform to the genre.
 The collaboration between Joseph and Flying Lotus is another
 example of the creative tension of works that create a mutuality
 between images and sound that exceeds the musical tracks that
 animate and enliven them. For this reason, I engage video as a
 sonovisual text in ways analogous to my reading of *Wildcat*.

7 In my 2018 blog "Black Visual Frequency: A Glossary"
 commissioned by the Fotomuseum Winterthur, I define still-
 moving-images as: "images that hover between still and moving
 images; animated still images, slowed or stilled images in motion or
 visual renderings that blur the distinctions between these multiple
 genres; images that require the labor of feeling with or through
 them" (https://www.fotomuseum.ch/en/explore/still-searching/
 articles/154951_still_moving_images).

8 This recitation within the film is taken from Chris Marker's
 experimental film *Sans Soleil* (France, 1983, 103 minutes, color, 1.66:1,
 French).

9 Roy DeCarava and Langston Hughes, *The Sweet Flypaper of Life* (1955;
 repr., New York: First Print Press, 2018).

Verse Three

An earlier version of this chapter was published as "The Visual
Frequency of Black Life: Love, Labor and the Practice of Refusal,"
Social Text 37, no. 3 (2019): 25–46.

1 Tina M. Campt, *Listening to Images* (Durham: Duke University Press,
 2017).

2 Arthur Jafa, "69," in *Black Popular Culture: A Project by Michelle Wallace*, ed. Gina Dent (Seattle: Bay Press, 1992), 254.

3 Jafa, "69," 267.

4 This excerpt is quoted with permission from Isaac's marvelous final paper, a "Practicing Refusal Glossary," submitted for my 2018 seminar The Practice of Refusal, taught at the Columbia University Institute for Research on African American Studies.

5 Jafa, "69," 267.

6 Huey Copeland, "Love Is the Message, The Message Is Death," *Black One Shot* (blog), June 4, 2018, http://asapjournal.com/love-is-the-message-the-message-is-death-huey-copeland/.

7 Christina Sharpe, *In the Wake: On Blackness and Being* (Durham: Duke University Press, 2017), 20–21.

8 See my introduction of this term in "The Visual Frequency of Black Life: Love, Labor, and the Practice of Refusal," *Social Text* 37, no. 3 (2019): 25–46.

9 Campt, *Listening to Images*, 72.

10 The concept of hapticity I develop here differs in important ways from the idea of *hapticality* articulated by Fred Moten and Stefano Harney, which they describe in *Undercommons* as "the capacity to feel through others, for others to feel through you, for you to feel them feeling you, the feel of the shipped is not regulated, at least not successfully, by a state, a religion, a people, an empire, a piece of land, a totem. . . . Thrown together touching each other we were denied all sentiment, denied all the things that were supposed to produce sentiment, family, nation, language, religion, place, home. Though forced to touch and be touched, to sense and be sensed in that space of no space, though refused sentiment, history and home, we feel (for) each other. . . . This is our hapticality, our love. This is love for the shipped, love as the shipped." Stefano Harney and Fred Moten, *The Undercommons: Fugitive Planning and Black Study* (New York: Minor Compositions, 2013), 98–99.

Verse Four

1 André Lepecki, *Exhausting Dance: Performance and the Politics of Movement* (New York: Routledge, 2006), 57.

2 Lepecki, *Exhausting Dance*, 122.

3 Rachel Anderson-Rabern, "Efficiencies of Slowness: The Politics of Contemporary Collective Creation" (PhD diss., Stanford University, 2011). See chapter 4, "The Ethics of Velocity."

4 https://www.artic.edu/artworks/248575/ night-coming-tenderly-black-untitled-1-picket-fence-and-farmhouse.

Verse Five

1 As quoted by Sharifa Rhodes-Pitts in "For Her Own Pleasure and Edification," The Hugo Boss Prize, Guggenheim, 2018.

2 Harriet A. Jacobs, *Incidents in the Life of a Slave Girl: Written by Herself*, edited by L. Maria Child (London: Hodson and Son, 1862).

3 Simone Leigh, "Loophole of Retreat," exhibition wall text.

4 Ed Pilkington, "'This Is Huge': Black Liberationist Speaks Out after Her 40 Years in Prison," *Guardian*, June 18, 2018. Debbie Africa was released on parole in June 2018. Of the remaining members of the MOVE 9, two died in prison, three others (including Michael James Africa Sr., father of Debbie Africa's child) were also released in 2018 and 2019, while three remain incarcerated. See also Ed Pilkington, "Move 9 Women Freed after 40 Years in Jail over Philadelphia Police Siege," *Guardian*, May 25, 2019.

5 Ed Pilkington, "Born in a Cell: The Extraordinary Tale of the Black Liberation Orphan," *Guardian*, July 31, 2018.

6 Seph Rodney, "Simone Leigh's Debris of Silence," *Hyperallergic*, July 31, 2019, https://hyperallergic.com/510618/ simone-leigh-loophole-of-retreat/

7 Rodney continues: "Leigh's work is not actually about evading the (likely White and dominant) gaze; it's about denying it a catalyst by which to act. These pieces of art cancel out the gaze because they don't yet exist in a collective lexicon by which they can be defined. In their hybridity they are incalculable, and in their incalculability they shush the room they occupy. . . . [T]hey create a zone of reserve. *Loophole of Retreat* tells me to check my impulses to seek out reciprocal recognition, and to not turn my reservation into awe, or fear, or an attitude of worship. This is the work that I have to do, and this is the work that needs to be done." Rodney, "Simone Leigh's Debris of Silence."

Verse Six

An early version of this chapter was published in *Flash Art* 327 (September-October 2019), https://flash-art.com/article/adjacency-luke-willis-thompsons-poethics-of-care/.

1 Gallery brochure, "Luke Willis Thompson: Hysterical Strength," curated by Edoardo Bonaspetti, Gallery of Modern and Contemporary Art, Bergamo, Italy, 2019.

2 Reprinted in Alex Greenberger, "'The Painting Must Go': Hannah Black Pens Open Letter to the Whitney about Controversial Biennial Work," *Artnews*, March 21, 2017, https://www.artnews.com/artnews/news/the-painting-must-go-hannah-black-pens-open-letter-to-the-whitney-about-controversial-biennial-work-7992/.

3 Nick Scammel, "Deutsche Börse Photography Foundation Prize 2018: Refusing Heaven or Confusing as Hell?," *ASX*, April 23, 2018, https://www.americansuburbx.com/2018/04/deutsche-borse-photography-foundation-prize-2018-refusing-heaven-confusing-hell.html.

4 Nicole Sealey, *Ordinary Beast* (New York: Ecco Press, 2017).

5 Eddie Chambers, "My Catechism: The Art of Donald Rodney," *Third Text* 44 (Autumn 1998): 53.

Index